Recessional

ALSO BY DAVID MAMET

Recessional

THE DEATH OF FREE SPEECH

AND THE COST

OF A FREE LUNCH

DAVID MAMET

BROADSIDE BOOKS

HarperCollins books may be purchased for educational, business, or sales promotional use. For information, please email the Special Markets Department at SPsales@harpercollins.com.

Broadside Books™ and the Broadside logo are trademarks of HarperCollins Publishers.

FIRST EDITION

Map on page 84 courtesy of the Federal Aviation Administration.

Library of Congress Cataloging-in-Publication Data has been applied for.

ISBN 978-0-06-315899-3

22 23 24 25 26 LSC 10 9 8 7 6 5 4 3 2 1

Against the Capitol I met a lion,
Who glazed upon me and went surly by
Without annoying me. And there were drawn
Upon a heap a hundred ghastly women,
Transformèd with their fear, who swore they saw
Men all in fire walk up and down the streets.
And yesterday the bird of night did sit
Even at noonday upon the marketplace,
Hooting and shrieking. When these prodigies
Do so conjointly meet, let not men say
"These are their reasons, they are natural,"
For I believe they are portentous things
Unto the climate that they point upon.

—Shakespeare, *Julius Caesar*, act 1, scene 3

Contents

Recessional

INTRODUCTION

I am a playwright. My professional life has been dedicated to the depiction of conflict.

If the drama is not a conflict, it can only be a lesson. The drama's antagonists are called characters; our knowledge of their character is limited to their actions: they made this or that choice, and it resulted in this or that outcome. The outcome was determined not by their "past lives," or "race," or social position, or sex, but by their choices.

Those of a religious disposition know that our free will comes from God and that free will only means the power to choose. A moral choice may or may not lead to an acceptable or good outcome. It need not; it *is* an outcome. It is a holy act, because it is moral—that is, in accord with divine will. If we were all good, we would not need free will, which is, finally, the possibility of courage. But we are not all good, neither is any of us good all of the time; in fact, one might say that the essence of human nature is that far from being "flawed," we are not very damned good at all. And we know it.

The repression of this knowledge is an engine of human wickedness. And we've seen, in this last year, that once begun, it must escalate, like a fire searching for air. For, in a convocation of the wicked, sinners contending for acceptance quickly find that safety in the company of

savagery can easily be sought in acquiescence, but *status* only in elaboration.

If restrooms must be redesignated to accommodate differing "genders," how much more worthy to assert that sexes do not, in fact, exist and then that men can give birth?

If Donald Trump is evil, must not anyone who questions the proposition be evil also? And, if evil, must it not be worthy that they be destroyed? And then that those who won't proclaim it share their fate? If speech should be limited to avoid "offense" to college students, how much more worthy to expunge the books, thoughts, and electronic footprints of any defending not only the offending matter but free speech itself?

We know that the side which sets the rules will not *eventually* win, but, on their assertions' acceptance, *has* in fact just won the contest.

Now we are engaged in a prodromal civil war, and American constitutional democracy is the contest's prize. The universities, and the media, always diseased, have progressed from mischief into depravity. Various states are attempting to mandate that their schools teach critical race theory—that is, racism—and elected leaders on the coasts have resigned their cities to thuggery and ruin.

The Left challenges the enraged, astonished, or grieving to "give it a name"*—its name is incipient dictatorship—and should the Left be allowed to steal another election, they will not be put to the task of doing it again.

Savagery appeased can only grow. As any know who've been involved in an abusive home, a vicious divorce, or the dissolution of a toxic partnership. There are two sides to the story only in those in which we are not directly concerned. Then there is only one; and that the truth must always lie "somewhere in between" was disproved by Solomon himself. Sometimes it does and sometimes it does not. Which is why we have rules for debate, one of them our Constitution.

* That is, to claw back sufficient distance and equanimity to think beyond retail affronts and dare to name the wholesale assault.

But how may a debate (a discussion, a trial, an election) take place in which one side rejects not its opponent's position but his right to exist?

When there is no answer to the question, the rational being must learn to ask a different question.

My question, watching my beloved American democracy and culture dissolve, was, "What can I do?" I found no answer. But I realize, a year on, that a *different* question has brought *me* closer to peace. That question is this: How might I achieve clarity?

These essays, written during that terrible year, are a record of that attempt.

THE FOUNTAIN PEN

Parsons in pulpits, tax-payers in pews,
Kings on your thrones, you know as well as me,
We've only one virginity to lose,
And where we lost it there our hearts will be!

—Kipling, "The Virginity" (1914)

I write with a fountain pen. I bought it on Lexington Avenue in New York, December 31, 2000.

I've had ink on my hands most of my life. I grew up with ink on my hands. The oak and iron desks in the 1950s Chicago public schools still held the glass inkwell, and there was then a debate about allowing students to hand in assignments written with the newly invented ballpoint pen.

I was the editor of my high school newspaper. I wrote the whole thing and set it in type on a wooden compositor's stick. The type came out of a California Box, so named because it was the basic, portable set of characters carried by the pioneers who headed west to find a likely spot and set up a newspaper. Mark Twain set type out of a California Box, a process not at all different from that used by Johannes Gutenberg.

I portrayed Gutenberg for the West German Pavilion at Expo 67, the Montreal world's fair. I was dressed in what I suppose was fifteenth-century fashion and worked an 1800 model of his 1439 invention, inking a block and pulling sheets from the press, happily covered in ink.

The Park Forest Star in Illinois took notice of my sports articles in the high school paper and hired me to cover high school sports in the area. I was paid four dollars an article, my first income as a writer. Sixty years ago.

Chicago's literary tradition derives from journalism. Dreiser was a newspaperman, as were Carl Sandburg, Eugene Field, Ida B. Wells, who was born into slavery and dedicated her life to the eradication of racism, Frank Norris, who called out the trading pit and the railroads, and, of course, Ben Hecht.

He and Charles MacArthur wrote the greatest—in any case, the most transformative—American play, *The Front Page*. Do read his sketches of city life, *A Thousand and One Afternoons in Chicago* (1922), dashed off and perfect; and see also his contemporary Finley Peter Dunne and his comic creation Mr. Dooley, the great Irish sage and bartender.

There was no better school for a writer than journalism. One learned on the instant, or got out: to get it right, get it fast, keep it simple, and pay it off. Damon Runyon (1880–1946) wrote sports for Hearst and took his wry genius with him into covering news (in addition to playwriting, screen writing, short stories, and novels). He covered the Lindbergh trial for Hearst, as did its other ace crime reporters, Adela Rogers St. Johns and Dorothy Kilgallen.

Kilgallen became America's most famous journalist. She had a daily column, "The Voice of Broadway," in 140 papers. She had a daily radio program and a weekly appearance on the television show *What's My Line*.

She was the only reporter to interview Jack Ruby; the information she gained sent her to New Orleans on the trail of Kennedy's actual assassins, and she returned to New York announcing she was going to print the truth and was discovered dead the next morning from an overdose of "You got too close."

Martha Gellhorn (1908–1998) worked, out of college, for the Federal Writers' Project with the photographer Dorothea Lange, documenting the Depression and the dust bowl. She was a friend of Eleanor Roosevelt, herself one of the most influential journalists of the twentieth

century. Roosevelt's "My Day" was a nationally syndicated column. From 1935 to 1962, she wrote as an advocate for civil rights, the rights of women, the UN, and the New Deal.

Gellhorn covered wars from the front (definition: when there is nothing between you and the enemy) from Spain through Vietnam. She was the twentieth century's greatest war correspondent. Her coequal was W. C. Heinz. He wrote that the soldiers got up every day to fight, as they had to in order to live, and the correspondents went with them, as they had to in order to live with themselves. He, incidentally, wrote the film *M*A*S*H*, and *The Professional*, one of the great novels of boxing.

Ralph Ellison and Richard Wright both wrote for the papers, as did Itzok Granich (Mike Gold, *Jews Without Money*), each writing about and for the benefit of his race. *The Chicago Defender* and New York's *Amsterdam News* were the voice of Black America during the long night of segregation, trusted and relied upon, as was the Jewish *Forward*, published in Yiddish and English.

Shakespeare called actors "the abstract and brief chronicles of the time." But, in my time, it had been the newspapers. Now, like the Deacon's One-Horse Shay, we are going to pieces all in a day.* The three engines of cultural cohesion, those evolved to air and help adjudicate differences, are upon their death couch.

Education, and the universities in particular, have long been beneath polite notice. Their cupidity, cowardice, and greed have been evident and decried for a hundred years.† It was thought sufficient in the 1960s

* You see, of course, if you're not a dunce,
 How it went to pieces all at once,—
 All at once, and nothing first,—
 Just as bubbles do when they burst.
 —Oliver Wendell Holmes, 1858. His poem about the first one hundred years of our Republic, portrayed here as the Deacon's carriage.

† See Robert Herrick, *Chimes* (1926); Thorstein Veblen, *The Higher Learning in America* (1918); Randall Jarrell, *Pictures from an Institution* (1954); Mary McCarthy, *The Groves of Academe* (1952); and Allan Bloom, *The Closing of the American Mind* (1987).

to indict them as football factories. One may now mourn for those innocent days.

Politicians have always been a confederation of whores, now betraying, now colluding with that opponent now promising gain, both in league, finally, against the electorate. But the newspapers. What words can convey my sorrow at their transmutation into organs of state propaganda? Worse than that, they have become unashamed merchants of hatred and panic.

I am surprised that it breaks my heart, for, of the three organs, I've been most closely tied, the last sixty years, to the press. A playwright without the initial imprimatur of the New York press can gain no larger notice, and so no income. After the newspaper strike of 1978, the imprimatur could be granted only by that first among inferiors, *The New York Times*.

I've benefited from the support of two, and suffered under the implacable opposition of many journalists, and was only heard to whimper by anyone in my vicinity. But to see the whole damned thing turn pear-shaped broke my heart.

Caran d'Ache is a Swiss manufacturer of the finest writing instruments. It was founded in 1915 and named for Emmanuel Poiré, a Russian-born French caricaturist—*caran d'ache* being a transliteration of the Russian for "pencil." He was famous for his anti-Semitic caricatures in the French newspapers and journals of the turn of the century.

French newspaper circulation quadrupled during the years of the Dreyfus affair (1894–1906) from the first false accusation, through his conviction, banishment to Devil's Island, and two subsequent trials.

La Libre Parole, founded in 1892, made its publisher, Édouard Drumont, rich, hammering, day by day, incitements to hatred and riot and shunning not only the processes of reason but the very existence of fact. *La Libre Parole* and the anti-Dreyfus movement immediately progressed from the call for death to the (wrongly accused) Dreyfus to a call for death for his coreligionists, the Jews.

A journalist from Vienna's *Neue Freie Presse* covered the trial. He was an assimilated Jew, Theodor Herzl. He was stunned to find France in an anti-Semitic frenzy. In the placards at Dreyfus's trial and humiliation calling not for "death to the traitor" but for death to the Jews, Herzl foresaw the European extinction of Jewry.

This genius looked on Paris in 1896 and saw the inevitability of Dachau. He wrote *The Jewish State* in 1896. It led to the First Zionist Conference in 1897 (my great-uncle attended), and fifty years later Herzl's vision became real, in the founding of the Jewish state.

But *La Libre Parole* and its like were a template for later anti-Semitic publications, notably, the Nazi *Der Stürmer* and, closer to home, Henry Ford's *Dearborn Independent* (1919–1927), an anti-Semitic publication force-distributed to all Ford dealerships.

The model—continued, unremitting hate mongering—has now been adopted with one or two exceptions by our national press.

Jefferson said that given the choice of government without newspapers or newspapers without government, he would unhesitatingly choose the latter. Now we have newspapers insisting on the infallibility of the state and calling out dissent as heresy.

What a history there is in one fountain pen. A vile anti-Semite drew hook-nosed Jewish fiends to pay the rent. An assimilated Viennese Jew saw in the psychotic frenzy the eradication of the Jews. His vision led to the existence of the Jewish state, the first refuge in two thousand years, from state anti-Semitism.

Meanwhile, the media screams that the end of the world is at hand. The ancient business strategy, the incitement to fear, and thus hatred, is rediscovered. The corporations, the interests, the trusts, the special interests, the kulaks, Negroes, immigrants, Jews, the rich, the bourgeoisie, all these colorful, infinitely applicable terms have had their day, and now we find "the haters," a term so weak it suggests a culture so fatigued and dispirited it is unable even to celebrate hate with a full heart; it is waiting to die. Which is what I have seen around me in this horrible year.

Inherited prosperity leads to sloth and then to greed and crime, as inevitably in the trust fund child as does state subvention in the welfare-raised gang member. They are both exemptions from work. The generations that worked for a living, and blessed the system that allowed them to do so, are on the edge of the grave, and rather than the looked-for period of leisure and contemplation, our vanishing store of energy is devoted to confusion, wonder, and sorrow.

I bought my pen December 31, 2000, at the Joon pen store on Lexington Avenue. The pen store closed in 2012, and Lexington has been closed by the virus panic and the riots.

Lexington was, for more than a hundred years, the small-business avenue of New York's Upper East Side. Madison housed the tony shops and restaurants, and Lexington the barbers, picture framers, bookstores, hardware shops, and so on.

Eric Hoffer wrote in *In Our Time*, ". . . the end of the trivial, mean-souled middle class that will sell its soul for cash will probably mean the end of civility, of tolerance, and perhaps of laughter. When they have gone, the country will have died."

Well, they're gone from the cities, and the liberal cities *have* died. The vanished and banished middle class has taken with it that expertise and ethos which, as Milton Friedman wrote, are a *possession* in which the populace has a right.

My house displays the Stars and Stripes. I think I am going to pair it with the Pine Tree Flag. It was one of the flags of the Revolution, a pine tree above the motto "An appeal to heaven."

The pine tree, *matsu*, or *matsuko*, in Japanese, is held by them to be the symbol of vigorous old age. The American experiment has come, in 240 years, to that fork in the road inevitable in any organism. We will either enjoy the respite of a vigorous old age or forgo that period and proceed directly and quickly to national death.

CAUSE AND EFFECT

—❦ ❧—

It is stunning how little money it takes to ruin a young man.

—Robin Maugham

A father who does not teach his son a trade teaches him to be a highway robber.

—Hillel

A young man—I speak only of men, being one myself, and the father of one—can't mature without an absolute conviction of the universality of the law of cause and effect.

When there is an intervening good fairy, the boy and the young man, being feral creatures, will exploit it. Teasing served to wean boys from Mama's skirts, bullying from various pretensions and discourtesies. Mama's skirts are a blessing, but to mature, which is to say to become independent, one must forgo them as a refuge.

Bullying is the unlicensed application of power. Of old, it consisted, among boys, in shoving, punching, and beating. Of late it allegedly includes mocking, name-calling, slander, and rough speech and, reappearing as "microaggression," can now be alleged by those who have affronted only by the color of their skin, or by "cultural appropriation" (a practice

previously understood as "emulation," a form of flattery); these allegations, of course, are but a new sort of bullying.*

The challenged young boy once understood the school as a distant and uninterested power, and his parents (in our beloved South, his father in the North) were as likely to counsel stoical forbearance, or, in fact, self-defense, as complaint (once known as whining).

To oppress the weak is reprehensible. But one will encounter bullies in every organization in life. He may have to submit to the martinet boss, or he may resist and risk termination. But the ability to assess the affront, possible reactions, and their costs was once learned in the schoolyard.

This assessment is based upon *cost*. The child who is mocked may hold his peace, and there may be a cost to his pride. He might determine that the bully will tire, guess the fellow's attention span, and weigh it against his inconvenience over that same period. If the bullying is physical, he might, of old, have appealed to the coach, who would instruct the concerned parties to "put on the gloves." If the victim judged this insufficient or, for whatever reason, unacceptable, he might take his complaint to the school's corrections officer (hatchet man), the vice-principal, or to his parents, and good luck to him.

Today, this parent finds, schools "take the allegation of bullying very, very seriously," which is to say they lose their heads and fall all over themselves in fear of community censure, or legal action.

The application of common sense is still discernible in some American institutions. The schools are not one of these. The appearance, or the mere allegation, of oppositional behavior sends our school administrators to *their* mama's skirts and the comedy of "peer moderation." Here the Freudian chickens have engendered a culture of constant and communal whining.

* The cry of "microaggression" is not new. It is the peremptory challenge of a protected group, employable ad lib, against its inferiors. In the segregated South it was known as "reckless eyeballing," in the military as "silent insolence," meaning "you seem to have forgotten you are subhuman."

Once the otherwise unengaged lay on a couch and complained to old Jews who had rusticated for decades in school to earn the right to eavesdrop. Now, short of altercations deemed of sufficient danger for the police, the two parties are sat across a conference table, and a peer moderator suggests they confess or confect their feelings.

Today's kids, like all American students of old, welcome any opportunity to get out of class, and what could be more pleasant than playing Perry Mason for the benefit of school administrators thus proved too stupid to understand the kids were putting them on?

The young schoolboy was instructed never to pick on anyone smaller than himself (a moral injunction), but to refrain from picking on those larger was a practical (that is, indelible) lesson in cause and effect. Or was, until the algebra of microaggressions allowed the weak to enjoy bullying the strong, and thereby court not harsh instruction but reward.

Today thugs, rioters, and thieves destroy our cities. They've done the cost-benefit analysis, and find they risk nothing, and, like the children in peer mediation, enjoy the concern, that is, the approbation, of those who are paid to control their behaviors.

We may enjoy but we do not value that which was given us, unless we are *instructed in reverence* for God, for the country, for the family, for human life, for personal property.

Absent reverence, the only control on human behavior is force or the threat of force (the law), or the desire to avoid its power (reason, conscience, or even in their absence the ability to weigh risk and gain). If the child does not observe reverence, if he does not see it in the family, or in the place of worship, or in the schools, where will he learn it? He will not. If he, additionally, does not learn the rules of cause and effect young, if he doesn't have to work for those things he desires, he won't learn it at all. It is as impossible as putting the unschooled in a helicopter and asking him to fly it, told only that it goes up and it can come down.

I have no idea why women marched on Washington during the Women's March, but must conclude they did it to get out of the house and

mingle with their like. As men once went to conventions, as an escape from marriage.

What, otherwise, was the benefit of putting on Till Eulenspiegel caps, pink "Pussy Hats," and demanding immediate correction of some indefinable wrong?

Here's a time line.

Aristophanes's *Lysistrata* was first performed in 400 BCE. Here the Greek women are disgusted at their husbands' inability to end the Peloponnesian War. They deny them conjugal rights, until they bring about peace. It doesn't work out very well, but at least it's an arguably rational calculation.

Lady Godiva (990–1067) was the wife of Leofric, Earl of Mercia. Legend had it that she was upset about his imposition of unfair taxes on his peasants, and so she rode naked through the streets.

My imagined dialogue:

MERCIA, 1035, THE GODIVA HOUSEHOLD:

LADY GODIVA: Leofric . . . ?

LEOFRIC: Yes, Barbara?

LADY GODIVA: I'm concerned about your oppressive taxation of the poor.

LEOFRIC: What do you suggest?

LADY GODIVA: Well, I'm going to take off my clothes and ride through the streets naked.

(PAUSE)

Vide: The Women's March. What did the women wish to bring about? And how was the march going to effect it? No one has been able to tell me. I know they were "protesting" Donald Trump, but what does this mean? To protest a person?

They were incensed, or enjoyed claiming to be, by an overheard (eaves-dropped), unpleasant comment.

A more enlightened male population would understand their hegira as one did the age-old pretext "Honey, I have to go to the convention in Cincinnati. That's where one makes contacts." But everyone knew the "contacts" explanation was an excuse. The husbands, however, did not understand that their *wives* knew it. Where are the men in the coastal cities' matriarchies who could make an enlightened assessment of the Women's March?

It is a most natural human urge to celebrate. The Women's March was, like the church social and Friday night football, an excuse to get together and to *differentiate one day from another*. Such events were once called holidays and dedicated to endorsement of some notion, event, or person. Now these have been amalgamated (Presidents' Day, rather than Lincoln's and Washington's Birthdays), abolished (Columbus Day), or repurposed as an award of the government (the placement of once date-specific celebrations to create the three-day weekend).

The COVID hysteria isolated Western citizens, under the threat not only of the virus but of governmental penalty. But leftist protest and riot were *exempt*. The state thus prescribing the *only acceptable mode of congregation*; to question the phenomenon was to invite censure and retribution. This is one cost of the Women's March: that the Left dared anyone to ask "why."

Absent the instruction in costs and benefits, the child grows warped. He will always search out the community that will accept, employ, or exploit his lack of self-direction. He finds acceptance among those similarly crippled by parental support, welfare, or a government happy to pay for his continued infantilization (college). He may enjoy its culture of complaint if supported by his parents or the state, but who would actually work *for years* to pay for "an education" promising nothing other than the waste of time and the inability to get a job?

Today's university student *knows* that he will never pay for his years in the theme park. Even the motivating factor of bad debt is gone; hasn't the Democratic Party assured him it will be expunged, as his right?

The mouse will not bell the cat. The cat, here, being the necessity of self-support in the bad, bad world.

The Left is attractive to the young, because it asserts that they need not confront the monster (maturity); that they, the Left, will simply pass laws and then more laws compelling the cat to bell itself.

REDS, PINKS, AND GOO-GOOS

> The wicked are wicked no doubt, and they go astray and they fall, and they come by their deserts; but who can tell the mischief which the very virtuous do?
>
> —Thackeray, *The Newcomes*, 1853

Lincoln Steffens (1866–1936) was the twentieth century's preeminent muckraker. These were the prototypical "investigative journalists" of their day. His book *The Shame of the Cities* (1904) is a catalog of political corruption familiar to anyone today of moderate perspicacity.

On the one hand, he showed the monopolists using the politicians to squeeze the country dry and, on the other, the anarchists, squeezing the monopolists.

He classed the Left (in descending order of power) into Reds (anarchists and Marxists), Pinks (intellectuals), and goo-goos (those whom Lenin tagged "useful idiots").

My own ordering has long been, bottom to top, fools, wicked fools, and savages.

I don't think the goo-goos are less guilty than their more active brethren, for today's savages, the Marxists, anarchists, and race hustlers, could not practice their depredations without the complicity of the mass.

The goo-goos of the early twentieth century were the saints of

the mid-century intelligentsia and their offspring. Margaret Sanger and John Dewey were the prophets, respectively, of eugenics and "learning through doing," which is to say noneducation, which is to say slavery.

The great Francis W. Parker School, where I spent my last two years of high school, had, inscribed over the auditorium proscenium, this quotation of Dewey's: "A school should be a model home, a complete community, an embryonic democracy." None who attended the school ever forgot it. But what did it mean?

It meant that it was the job of educators to raise children. It was not the job of the home but the mission of the *elites*—propounded by the schools. This was the progressive echo of Jane Addams and her settlement house movement.

Miss Addams worked heroically in the slums, aiding new immigrants. But there is a difference between helping immigrants acclimatize to a new environment and teaching them how to raise their children. We see the unfortunate echoes of the philosophy in the miserable wreck that the welfare state has made of the inner cities.

Margaret Sanger believed in euthanasia and sterilization of "unfortunates," the mentally challenged, and Blacks. She was the founder of Planned Parenthood, which, like all organizations, expanded its brief (originally one of control of subhumans) into control of all conception.

Her insights were taken up in the 1960s when "hygiene" classes became "sex education," educators holding that because perhaps the children were not taught at home, the higher orders needed to take charge. And now we have kindergartners trained in a bizarre catechism of sexual identity politics.

How could a school be a complete community? The church or synagogue was not, neither was the shop or business. Each was understood to be a *part* of a community, a community that would thrive as each of its components contributed its own unique efforts.

A school could be a complete community only if all other aspects of the community were destroyed. The Hitler Youth could be a complete community. It was a gang. The gang exists to supplant both the family and

the marketplace, as we now see with education, having taken upon itself schooling not only in sexual practices but in political (and so economic) direction.

But if a school were, and was to continue as, a complete community after the student's matriculation (if it was *complete*, into what other community could the student pass?), he would have to remain bound to the school. How could that be done? By denying him an education.

Thus the "complete community" of the school metastasized (if the *school* could not be "life," then all life would have to be a school) as its graduates dispersed and poisoned the wider society. Just as blue state liberals, having raised taxes and regulations to the ruin of their home states, leave for pastures more green and vote to desolate them, too.

The liberal educated, never having learned the skills for self-support, or of rational political difference, carry their false "community" into the wider world, re-creating the seminaries of their youth in insulated and hermetic neighborhoods.

The closest mankind can come to a complete community is slavery, and even then we have the differentiated class of the slavers, overseers, *nomenklatura*, and house servants, with each group forming a community of its own.

And a school cannot be an embryonic democracy. It cannot be a democracy at all, for, given the democratic "one person, one vote," the students could carry any measure. The assertion, then, is made in either hypocrisy or ignorance.

The latter, of course, is the province of the goo-goos, the ideologues, the well-meaning, and, finally, those insulated from the results of their actions *by* their community with the similarly blessed.

The abusive, narcissistic, psychotic home is a fragile structure and can function only among the powerless (children) and the will-less. It replicates itself as the abused child becomes the abusive parent, as, likewise, goo-goos take upon themselves the dual role of slave and slave driver, creating ever-new and exacting demands upon themselves and their co-religionaries.

The habit of groupthink, absorbed in schools, is perpetuated in their graduates. For questioning, to the Left, is shunned as a very real psychic threat. They are infantilized by fear of exclusion, becoming like the abused infant, toddler, youngster, to whom to recognize abuse is to lose the only home he knows.

Public officials mandated the wearing of masks, then openly flouted their own regulations. Why did the Left not object? If the masks were essential to preservation of life, even the most depraved and corrupt of officials would, one would think, obey *that* law. If they are, thus *demonstrably*, not necessary to preserve life, why did the solons pass the laws?

And why didn't the co-opted populace ask the question?

The display of a face covering must, because the responsible officials doubted its utility, function as a religious symbol, like the burka. The comparison may be useful because the burka functions, practically, not to prevent the spread of disease but to prevent prohibited interactions.

But if the lockdown and the masks and social distancing were not intended (by officialdom) to limit disease (and because *they* do not obey the rules, we must assume that is not the lawmakers' intention), what good were they? Or, "who benefits?"

A look at the turn-of-the-century politics observed by Lincoln Steffens may help.

There was a tactic beloved of monopolists in the century of the labor wars. This was capital's answer to the strike and was called the lockout.

Here, factory owners would slash wages, increase hours, and expel from their companies any who did not comply. If the workers called a strike, the factory owners would close the factories, move manufacturing elsewhere, and leave the workers to starve or "come to see reason."

Not only were the union employees locked out, but scabs were, too, and so *no* money was coming into the locked-down town. The workers eventually had to submit to *any* demands of the factory owners. And they did. The owners could move manufacturing elsewhere, but the workers were tied to their families and homes.

The COVID "plandemic," however begun, and with whatever degree

of honest opinion, goodwill, and concern, quickly became a lockout: the factory owners—here, the state—destroyed the middle class whom they (rightly) feared would vote for less government taxation and regulation.*

Just as the factory owners pitted workers (union and non-union) against each other, in a race to the bottom, so the Left, their political machines, and the media have conspired to divide and conquer, covering every face and isolating the citizens from their fellow citizens, the threat being not a slow starvation, as before, but death by choking.

The school *should* not be a complete community, and a complete community *must* not be a school, because a school cannot be a democracy. It must be an autocracy.

It is a strategy of statism, which will eventually usurp power by asserting the pressing need for order, to name the beginnings of its quest "instruction."

* Note: Many urban properties, their values driven down, will be found to have been purchased not only by canny observers but by those who engineered the decline.

WHAT'S IN A NAME

———— ✴ ✴ ————

President Trump had been calling out the fake news since he declared he'd run. I'm with him there. In fact, an excellent preparation for dealing with blacklisting (my own) is a career as a playwright. The science of history burgeoned with the invention of movable type; it is now dying through the application of ink eradicator known as "the media." Soon it will be no more.

The Left, which has long held that facts were "cheating," has now come to deny that they, in fact, exist: men can give birth; children are born with no sex; we will all die from environmental sins in ten, twelve years. What will the creatures of coming millennia make of whatever runes remain?

I see on eBay a postcard for sale. There is a Blériot monoplane, nose down, crashed in a field in 1909. The caption, "Rough Landing, First Lap, Issy, August, 1910, Aviator Mamet." eBay lists it for $49.95 OBO as "Vintage Early Aviation Accident David Mamet Paris France." Well, it ain't me, who had not yet been a glint in my grandfather's eye. It is my xth-removed cousin Julien Mamet, Blériot's mechanic and, probably, the first Jew to fly heavier than air, should the future be listening.

And who would have thought that my name, so odd and foreign, would find itself bandied about in the marketplace? That's the name on my paternal grandparents' Russian passports (1922): Mamet and Mameta. That was their name in Russian Poland, and it probably is of Turkish or Arabic origin, as Mahmud, Mohammed, or the like.

I never liked the name and would have been glad to pass it off as French, restrained only by the fear of discovery. I gained strength and resolution, however, from the great Jackie Bisset, who, like me, has the *t* at the end sounded. And from the old English ditty:

Oh what a most important thing a consonant can be
For TWINING would be WINING if it were not for his Tea.

Too good.

But here I am, stuck with what I have always considered an unlovely name. My young son, however, was treated with great deference on its account. He is Noah B. Mamet, and that, one would think, unique name was also that of our ambassador to Argentina (2015–2017). Noah, aged four and five, received a certain amount of correspondence addressed to His Excellency.

What's in a name? Shaw wrote that any profession which communicates largely in jargon is make-believe. "Wellness" is a neologism, meaning "health." What was wrong with "health"?

But fashions change. That is the sine qua non of fashions. Derelicts become vagrants, then the homeless. The people are the same, but the social problem has been inverted into a political solution: rename and worship them.

Employees are now referred to as human resources. The folks described are the same, but the difference is semantic, which is to say, in the way they are considered, and, so, treated. What does one do with employees? One pays them. What does one do with resources? One exploits them.

Coca-Cola is just brown bubbly sugar water. It is also the most famous

brand in the world. The fool who decided to market "New Coke" is coun-
terbalanced by the marketing genius who promoted a Marxist-anarchist
America-hating group as "Black Lives Matter" (a sentiment with which
no one would disagree) and used the title to immunize themselves against
scrutiny of their operations.

This tactic was called out by Lenny Bruce in a skit about a singer
onstage, tanking. "All right," he says, "this next song is not for me. It's for
Al Jolson. Jolie, in showbiz heaven, give it up for Jolie."

"Wellness" is the New Coke of health, in that it clouds the issue. We
realize, except when ill or frightened, that each is in charge of his own
health, but "wellness" seems to enlarge the concern to a point where nei-
ther its object nor its attainment can be concisely stated. Thus attempts
to merchandise "wellness" products and treatments can be infinitely ex-
panded.

See also a concern for that phantasm called social justice, a concept,
like "wellness," of which one can never have enough and so may be sold
any amount.

We are not much given to titles over here. The Brits love preceding
and following their names with indicators of social position. They have
the various shades of knighthood and degrees of nobility, the addenda
of military decorations, and memberships in royal societies, along with
the plain-Jane academic degrees.

The titles announce a distinction valuable to their possessors, or
award to their possessors the hope that they will so function. Over here,
we have military ranks, academic degrees, the title of Doctor, and that's
about it.

Yes, the holder of office is addressed as Mister or Madame fill-in-the-
blank, but we are, happily, queasy about awarding an honorific to those
out of office, retired, still in there pitching, or just in the transition be-
tween office and jail. It's not the American way. We are a country of
citizens who have always prided ourselves on the ability to assess social
and moral worth based solely upon the display of wealth.

But now, O Best Beloved, the fashion for new nomenclature has been

taken up and, in fact, inscribed into various laws: see the notion that one must be addressed by any title he or she demands. The question occurs to me: "Or what?" And the answer is, "They will go wee wee wee all the way home," and the offender may be canceled, and his life ruined.

Operationally, this, rather than facilitating social intercourse, stifles it, and many, myself among them, are faced with the old poker choice: raise, call, or fold.

Call here means go along with the gag, fold, speak up and end the interchange, or get out of it and forgo any potential benefit to oneself.

But I have considered the raise, and here it is:

Someone demands to be addressed as X or Y, someone else, as A or B, and I may be sitting making notes around a diagram of the conference table. But then it comes to me to announce my title. In months past I fantasized demanding that I be addressed as Dr. Mamet, as one possessing honorary degrees from institutions that are now honorary universities.

But, to my dramatist's mind, this causes insufficient havoc. My current fantasy is to demand being referred to as, in both the first and the third persons, His Majesty–Your Majesty. Asked for further information, I could display the cold impenetrability of royalty and explain that I am a direct descendant of King David (who knows?), and the gophers around the table could, their choice, scream bullshit or go along with the gag.

My daughter Clara says, "Dad, this is you at a business meeting:

"Person A: 'It's an honor to meet you.'

"Me: 'Then why don't you go fuck yourself.'"

This is not inaccurate.

I can do several things well; the ability to make small talk as a professional tool is not among them.

Entertainment Executive: Mr. Mamet, it's such an honor to meet you.

I have never had a meeting that began thus in which the project did not either come to nothing or come to grief. Why? Because in the entertainment industry, as opposed to the American theater (1776–2020), I am an employee, and what boss would not regret treating a human resource with that ancient regime *politesse* once known as "courtesy"?

How, O Time, I preferred the "Let's do business" of the old studio era: one assumed then that one would not be in the office unless the other fellow wanted to do business, and the conversation then was, "Yeah, siddown, what are we talking about, who's in it? What is it going to cost, when can you start?"*

Once in a while, in my days as a fresh young thing, just visiting from the East, I was addressed as "Mamay." I always hated to correct them.

* This, by the way, is not the essence but the *totality* of the motion picture production business. What do all the executives and "producers" do all day? They loaf, gossip, scheme, and toady or domineer as required. Just as in any bureaucracy. Examples from their own experience will, no doubt, occur to readers.

PIPPA PASSES

I magine an individual taught it is unnecessary to work, to pray, to study, to marry. Expand the notion to three generations, and we see the results in our civilization that we would expect in the individual: terror.

The terror has been ascribed to impending global catastrophe—that is, the revenge of the sun, winds, and tides—or to an influenza epidemic, or to Donald Trump, or to "white supremacists."

These complaints are symptoms, and the good diagnostician would perceive their underlying identity.

But the confused and frightened individual cannot be a good diagnostician; he has been kept from it by the comorbidity, a real (and rational) fear of the mob. The "freedom" worshipped by my generation, the young of the 1960s, was never defined. From what were we supposed to be free? In the event, the imaginary quest led us, and our progeny, to deracination, that is, a freedom from roots.

The horror of global holocaust began with the invention of the atom bomb. The West's fear of the bomb was exploited by the Soviet Union in the Communist-funded "peace" movement. Westerners, supposedly intelligent, were taught (and came to believe it was an independent

perception) that global annihilation could be avoided only through uni-lateral disarmament. The Russians were not afraid of the bomb. It was, to them, like Dumbo's magic feather: it allowed them to do all things.

At the close of World War II, America was the most powerful country in history. But our new adversary, the USSR, held the bomb over us, a weapon so awesome the Western Left was induced to prefer surrender to the chance of conflict. But imagine an armed conflict that only one side is allowed to escalate.

A police officer holding a firearm on a criminal uses the threat of force to compel compliance. But if the criminal is assured the officer *will not fire*, the officer has not increased but *reduced by half* his potential weapons: the criminal has two hands, the officer, a useless gun in his hand, now has only one.

Further, the criminal now has the possibility of taking the officer's gun and using it against him. The armed officer has now turned from a keeper of the peace into a gun shop.

The wily criminal now, rather than avoiding confrontations with the police, may seek them out as opportunities for civil action, or as simply counting coup.* (Various states have recently proposed laws "decriminal-izing," which is to say outlawing, resisting arrest.)

The Soviet Union was assured the United States would not strike first and exerted massive efforts to ensure we would not strike *at all*; it's esti-mated by Stanislav Lunev in his autobiography, *Through the Eyes of the En-emy*, that the USSR spent one billion dollars funding the peace movement.

So assured, it was in the interest of the USSR to draw the United States into sub-nuclear conflicts. In these, the rules of engagement (for the United States) were set by the peace movement, which is to say by Soviet Russia.

There is no such thing as a limited war. He who sets the rules of the conflict, sets the rules of the peace, as Napoleon observed.

* See videos of rioters taunting police.

In Korea and Vietnam the Soviet Union held over us the threat of a nuclear war it knew we would never fight. So we squandered blood and treasure halfway around the world; Russia ordered its surrogates to fight: Red China and the peace movement. Our teenagers in Vietnam died in a "limited war." That is to say, a war proclaimed to be unwinnable.

A cop without weapons is in a better position than one with weapons he is forbidden to use; in the latter case he is just a security guard, which is to say a lawn ornament or sop to the notion of defense—present not to deter crime but to reassure shoppers.

A free citizen may choose to defend himself. But why would a shopper do so? He is content to let the aggressor set the rules: that the thief is free to steal, and the shopper free to *assume* the crime will not turn into violence.

In any existential conflict, the side that is willing to discard the rules will be the winner. This side will be that which understands, as a matter of course, that the rules *themselves* can be employed against an opponent.*

The imperial Japanese peace envoys to the United States were in conference with our officials in Washington as their warplanes were bombing Pearl Harbor.

Thugs in the streets of Portland attack the police and then throw up their hands and warble.

Barry Goldwater was running for president in 1964. Asked about the Vietnam War, he suggested the only alternatives were to "Bomb them back to the Stone Age or get out tomorrow." He was denounced as a warmonger and a psychotic. But what other choice was there, if we were involved in a war? For that was his question: Are we involved in a war? If so, *win* it. If not, *get out.*

* Note: President Trump called out Communist China, declared it our enemy and exploiter, and took steps to correct the situation. The Wuhan Institute of Virology in Wuhan accidentally loosed a virus on the West, which reacted by destroying its economy. Today, the corner cobbler asked me if I knew of any nearby property for rent, because the entire block had been bought by the Chinese.

His observation was exactly the same as that of Solomon, who brought the court to its senses by suggesting they cut the baby in half.

Conservative America, a constitutional democracy in a republic, has been facing its existential crisis since the Obama hegemony.

The chickens of prosperity have come home to roost, and a deep state, unfettered by law or custom, is using the essential lawfulness of its opponents (the citizenry) against them—in effect, *daring* the citizens to revolt by strategies and energies *superior to* those of their attackers.

The "it can't happen here" passivity of the liberals has matured into the complicity of determined ignorance. It *is* happening here. And it *has* happened here. Law-abiding citizens are being dared to demand the rule of law. To deny it is to accept the wisdom of the bumper sticker: "I would rather crawl on my hands and knees to Moscow than be the victim of a nuclear bomb." The strategy of Russia was revealed by the slogan "If you are fool enough to accept this choice, you have *already* lost."

In our magnificent country, "the lark's on the wing, the snail's on the thorn, God's in His heaven, all's right with the world."

God *is* in heaven, all has *never* been right with the world, and, to improve on Mr. Browning, "the fat's in the fire." And law-abiding Americans, anguished at the wreck the Left has made of this country, are wondering at the stroke of what midnight the Left will completely unmask and how little their visage then will differ from their current costume.

KING KONG

❧❧

Freud wrote that the only way to forget is to remember.

We find the same apparent oxymoron in Deuteronomy 25:19: "You shall wipe out the memory of Amalek (Evil) from under Heaven. You shall not forget." Proving, should proof be required, that the Bible's authors were pretty good Freudians.

The human mind differs from the animal in its capacity for association. This accounts for the faculty we call reason, and for that faculty's derangement into both art and neurosis. In these, cause and effect are scrambled, disguised, inverted, or otherwise reordered. In the case of art, the new relationship functions, potentially, in aid of a different and more beautiful (if not more reducible) understanding. Neurosis employs the same processes to camouflage the unpleasant or unacceptable.

The Miss America Pageant is, essentially, the reenactment of a slave auction. *King Kong* is, of course, a rape fantasy. Here the huge black creature wants the defenseless white woman so badly he is willing to die for her. He dies clutching both her and the world's biggest erection, overcome by the mechanical contrivances of the puny white men who, as unaided individuals, had no hope of combating his animal lust.

Should one miss the point, we have the film's tagline: "It wasn't the airplanes; it was Beauty killed the Beast."

The story's envoi reveals its absurdity, and thus the operation of the repressive mechanism: What was King Kong going to do with the girl when he "got" her? To expand the conceit, why was it an article of faith that African American male slaves possessed an insatiable appetite for white women?

Which brings us to Sammy Davis Jr. and Alex Gibney's superb documentary, *Sinatra: All or Nothing At All*. Here we are shown Frank's championship of Sammy Davis, fracturing the color line for Las Vegas Black performers, and the (for the times) extraordinary inclusion of Sammy as a near coequal member of Frank's coterie, the otherwise white Rat Pack.

The Kennedys and their Mob associates conspire to get JFK elected. Frank is the matchmaker. He becomes close with the Kennedys as he campaigns for them, as do the Pack's other members, and he looks forward, after Jack's election, to a seat near the throne.

Kennedy triumphs. Frank and the Rat Pack are invited to the inaugural. But during the campaign Sammy has married May Britt, a white Swedish actress. The Kennedys inform Frank he must disinvite Sammy. He complies.

How does the human being deal with his betrayal of those close to him? Traditionally, by dehumanizing them. Frank and his crew begin doing vile racist jokes while onstage with Sammy, and then he is banished from the Presence.

The repressive mechanism has functioned as designed, cause and effect are inverted, and the oppressor reimagines himself as the entitled victim.

The mechanism also works through the free exchange, or fungibility, of repressed ideas: a real shame may be traded for another which, *as confected* (that is, known to be false), is more acceptable to the conscious mind.

The southern white "slave-rape" fantasies defused the white shame at the practice of slavery by replacing it with the fantasy of Black sexual

insatiability, swapping victim and oppressor. The lucky possessors of this analgesic thus masked shame at their own actions, by outrage over a "shameful topic," of which chastity forbade the consideration.

Slavery is sin; sex, when moral, is merely private, but the urge for privacy is close enough to that for concealment to do rough duty as a substitute.

White outrage over the permitted fantasy served to excuse, and indeed to license, human chattel slavery.

It was not the white women of the slavery-Reconstruction-segregation days who were protected by the persistent delusion of Black insatiability. The fantasy served to protect the guilty mind from conscious scrutiny of its crime.

Mandingo and *12 Years a Slave* are after-echoes of the rape fantasy. Filmed as indictments of white mistreatment of Blacks, they are actually a "permitted," deniable celebration of Black inferiority. A contemporary white consciousness could not enjoy the sentiment per se and so presented it as an evil to be decried.

See also the myriad women-in-peril films (*Panic Room*, *Room*, *The Collector*, and so on), which are, mechanically, soft-core rape fantasies. In Holocaust films, my people, the Jews, are awarded a temporary status as honorary human beings. The audience is invited to feel sympathy in return for the assurance that we will end the film as soap.

The national hysteria of "the N-word" is instructive.

Here is a word so bad that utterance even of unconnected words of a similar sound must consign the speaker to immediate and irreversible poverty and shame.

The suggestion that African Americans are so fragile (that is to say, inhuman) that a mere sound can reduce them to lunacy has a clear precedent: it is the white southern woman's supposed inability to tolerate the slightest, most remote association between slavery and sex.

I saw the Modern Jazz Quartet performing in 1950s Chicago. The

African American musicians introduced their number "I've Got My Eye on You" by saying that when they played it down south, they were dead sure that they were looking at each other.

Not that long ago.

The racist vapors about white chastity and the current factitious white concern about Black sanity are operationally the same: they attempt to conceal the shame of white complicity.

It is the complicity of cowardice in participating in a monstrosity because it is licensed by the group. The cowardice today is in acceptance of the sick lie that Black people are somehow subhuman.[*]

Sixty years ago the Modern Jazz Quartet shared with its white audience a joke from its own community about racism and sexuality.

Here is another:

Lately various "repentant" whites fell to their knees in front of Black Americans.

The phenomenon was noted by de Clérambault, a French psychologist, in 1885. It's known as de Clérambault's syndrome, or, in his words, erotomania; it is characterized by the delusional idea, usually in a young woman, that a man whom she considers of a higher social or professional standing is in love with her.[†]

In kneeling, the delusional liberals offer themselves sexually to those they delight to consider more powerful, acting out the passive side of a rape fantasy.

[*] Note: What is the difference between the slave owner's conviction that Blacks were too stupid to be educated and today's white liberal mantra that they are too fragile to get through the day without being devastated by some "mini-aggression"? The first assures the idiot white that Blacks are actually happier in the slave quarters, the second that they are happier on welfare and on the fainting couch.

[†] From Harold W. Jordan and Gray Howe, "De Clérambault Syndrome (Erotomania): A Review and Case Presentation," *Journal of the National Medical Association* 72, no. 10 [1980].

Some (Mainly) Musical Revelations

⟳

Someone once said they'd like to be inside my mind for half an hour. I was pleased to be able to quip, "You wouldn't like it."

I've played the piano all my life. I don't understand the audiophile's occupation with the quality of sound reproduction; I couldn't care less. But I do love music with what might be a Pythagorean affection.

I delight in knowing, for example, that the bridge to Berlin's "Blue Skies" is "Hatikvah"; that "Auld Lang Syne" and "Bring It on Home to Me" can be sung against each other as a double song (try it); that "(Back Home Again in) Indiana" (1917) is just Dresser's "On the Banks of the Wabash, Far Away" (1897) in double time.

And here are two late revelations.

From the film *The Wizard of Oz*, 1939:

There I was at the piano, weary and ill at ease (see below), and playing "When I See an Elephant Fly" (Oliver Wallace, music, and Ned Washington, lyrics).

This is a hysterically funny group of puns.

You may recall that someone tells the crows that Dumbo, the elephant, can fly. They begin trading quips:

I've seen a horse fly.
I've seen a *house* fly . . .

Some of which are specific references to the music of the period, for example, I heard a screen door swing; and (my favorite), I saw a sawhorse rear up and buck. And they tell me that a man made a vegetable truck.

Now, it's not bad that, as all of that era knew, a sawhorse was used to "buck" up the wood—that is, hold it for sawing. But the contemporary audience must have been delighted at the subsequent pun about the vegetable truck, for were they not in the midst of the craze for the wonderfully outlandish figure in swing dancing: trucking (see R. Crumb's iconic poster, "Keep on Truckin'")—that is, a crouching duck walk performed one hand held high and oscillating in an admonitory manner?

But imagine my surprise on segueing from this to "Ding Dong the Witch Is Dead." I began mucking around in the bass clef, a delight because my piano is an 1885 Steinway, valued among musicians for the clarity of its bass. Popular culture holds that the Steinway designers of that day were hard of hearing in the low register. In any case, it's a great instrument for banging away with the left hand.

Doing which I discovered that "Ding Dong" is essentially an homage to Prokofiev's overture to the *Lieutenant Kijé Suite*—this commissioned for the 1934 film *Lieutenant Kijé* and used again, magnificently, by Ronald Neame as the theme for his 1958 film, *The Horse's Mouth*, written by and starring Alec Guinness.

Lieutenant Kijé is an imaginary soldier put on the books due to a typographic error. On its discovery none of the military bureaucrats care to take the blame, so they invent a record and an existence for him. The gag was employed, memorably, in "The Court Martial" episode (season 1, episode 25) of Phil Silvers's television show, *Sgt. Bilko*, as Harry Speakup.

Here a chimpanzee wanders into the line of recruits drawing clothes from the army quartermaster. Everyone is busy and harried. The clerk, head down, asks the chimp to give his name. The chimp does not respond,

the clerk says, "Speak up, Harry." And his assistant inscribes the chimp in the roster as Harry Speakup, under which name he is inducted into the army.

Today I received a letter from a pen pal. He mentioned that a friend of his, an old submarine captain in the diesel days, had printed on his calling card "REV. 19." So I went to Revelation 19 and found, "And again they said, Alleluia, and her smoke rose up for ever and ever."

This, to one raised on the fake book and the songs of Tin Pan Alley, was the purest gold. Some may collect wives, or art pottery; I adore the arcane. For the New Testament verse is also found, now in the vulgate, in "The Oceana Roll" (1911). This is a song about the piano player Billy McCoy, who was a musical boy.

> *On the cruiser Alabama, he was there on that piana,*
> *Like a fish down in the sea*
> *When he'd rattle off some harmony . . .*
> *Each fish and worm begins to twist and squirm*
> *The ship starts in to dip and does a corkscrew turn*
> *Just see that smoke so black sneak from that old smokestack!*
> *It's floatin' up to heaven and it won't be back.*

Was the lyricist of this, my favorite line in all of songdom, alluding to the Revelation of Saint John? We can't know. But here is a gag, long past its expiration date, but a delight to the collector.

My dear friend Mary Ann Madden wrote the wordplay competition in *New York* magazine (1969–2000). Each week she'd issue a new challenge to us would-be gag writers and print her choice of the winner two weeks on. (Example: Change one letter of a well-known title or phrase. Winner: Lincoln Center for the Performing Ants.) I've long regretted the passing of the competition, for I came up, quite lately, with two boffo, surefire winners (twenty years too late). Both, allusions to the wonderful film year of 1939: *Gone with the Wino*, and "Some Whore over the Rainbow."

To conclude the promenade with a musical example. Miss Madden issued this challenge: match a popular title or phrase with a false attribution. The winner was "Seated One Day at the Organ, Weary and Ill at Ease: Linda Lovelace."

I don't care where the snows of yesteryear are. I presume they are melted, and so be it. But I sorely miss the hip, ultra-literate, smart-ass autodidact mob from Elaine's (New York's 1970s "Round Table"), which supported the wordplay competition (and the rest of that late-century, vibrant American culture).

"Seated one day" is the opening line of one of the most famous of mid-Victorian songs, "The Lost Chord."

"The Lost Chord" was an 1858 poem by Adelaide Procter:

Seated one day at the organ,
I was weary and ill at ease,
And my fingers wandered idly
Over the noisy keys.

Arthur Sullivan set it to music in 1877. It became a sensation and might have been the first Edison phonograph recording ever played in England (1888). Linda Lovelace was a pornographic actress, the star of the 1972 film *Deep Throat*.

TWO HANGINGS

All the schoolchildren of the last mid-century knew Nathan Hale as a hero of the American Revolution. He spied for General Washington and was caught by the British and hanged in 1776. His dying words were "I only regret that I have but one life to lose for my country."

Edward Everett Hale (1822–1909) was a Boston writer, abolitionist, and, later, chaplain of the U.S. Senate. He was a direct descendant of Nathan Hale.

All my schoolmates knew his short story "The Man Without a Country."

Its hero, Philip Nolan, was a follower of Aaron Burr in Burr's attempts to collude with Spanish or French in Louisiana to establish a new country. Burr's perfidy was uncovered, and he fled to Europe. But his disciple Nolan, a serving lieutenant in the U.S. Army, was apprehended, tried, and found guilty of treason. Before sentencing, the judge asked him if he had any words of extenuation, to show he had once been faithful to the United States. He replied, "Damn the United States, I wish I may never hear of the United States again."

This was his sentence: he was taken on board a U.S. naval ship in

1807 and passed from ship to ship, never in sight of the United States, never hearing a word of it from any shipmate. All books, maps, and periodicals mentioning his country were censored. He lived on shipboard until his death in 1863.

It was a harsh and, of course, illegal sentence. Edward Hale explains that the case got lost in the Washington bureaucracy, and no attempts to amend his sentence ever reached the ears of any empowered to do so.

Nolan served heroically, on shipboard, in the War of 1812. He won the affection and admiration of the generations of officers who knew him, but he never heard of his country again until his deathbed. Texas, California, Ohio, the Civil War, all were unknown to him.

As he lay dying, a fellow officer relented and filled Nolan's last hour with American history. He drank in the news of the country he had damned.

He asked to be buried at sea, and a plaque erected somewhere, "that my disgrace may not be more than I ought to bear," the plaque to read,

In Memory of
PHILIP NOLAN,
LIEUTENANT, IN THE ARMY OF THE UNITED STATES.
He loved his country as no man has loved her, but no man deserved less at her hands.

At breakfast today I mentioned to a friend that I planned to write about the story. "Yes," he said, "and it was *a true* story, too, *wasn't* it . . . ?" No, it was not.

Hale wrote that from the time of the story's publication as a book (1888), and throughout his life, he received letters from those claiming to have known Nolan, or Nolan's brother or sister, or announcing they had come across some of Nolan's journals, and so on. How this must have delighted him, to find his creation so close to the American heart.

Nathan Hale was hanged in 1776 under the laws of Great Britain, a country from which the United States had declared itself separated.

William Joyce was hanged for treason in 1946, under the laws of Great Britain, a country of which he was not a citizen.

Joyce was born in the United States to British subjects. They returned to England with their infant son. In the 1930s he took up with the pro-Nazi British Union of Fascists. He left Britain for Germany and became a Nazi in 1939.

He was the most famous of the Nazi radio "personalities" known as Lord Haw-Haw. Hitler's *Germany Calling* spread these broadcasts of misinformation and treason, in English, to the Brits (later the Allies) in Europe and North Africa. Joyce was apprehended at the war's end, in Germany, and shipped back to England to stand trial for treason.

His defense contended that he could not be guilty of treason, because (1) he was not a British subject but an American—yes, he had fraudulently obtained a British passport, but the very fact of the necessity of falsity could be argued as a refutation of his British nationality—and (2) he left England for Germany in 1939, when his native country, the United States, was not yet at war.

The British were not amused. He was convicted. He appealed, and the sentence was upheld. He was hanged for treason on January 3, 1946. His defense contended that the British had no legal jurisdiction over one who had never been a citizen. The court held that he had accepted the protection of the Crown from his infancy, wherever he had been born, and that he had thus incurred an obligation to abide by the country's rules. The most obvious of these was *not to work for its destruction*.

He was the last person to be executed for treason in the U.K.

Now we see the fashion of that innovator, Colin Kaepernick. He loathes the country whose citizens have made him rich and famous. He is free to do so, protected by the laws of the country he decries.

Athletes accept salaries from a viewership not separated by political opinion. Kaepernick and his political like do not reject one-half of the money collected, as tainted by the donor's politics. They take it all, then

affront and appall at *least* one-half of their supporters and call the affront an act of conscience. It would be an act of conscience to refuse half of their salary, or to refuse to play in front of a public whose politics they loathe. Their kneeling and posturing is merely an act of theater. It cannot be an act of conscience, for the players risk nothing in their supposed defiance while accepting the rewards of their mock heroism.

Edward Everett Hale quotes Scott's poem *The Lay of the Last Minstrel* in his story. This, like the story itself, was known to all mid-century American children:

> *Breathes there the man, with soul so dead,*
> *Who never to himself hath said,*
> *"This is my own, my native land!"*

Scott's poem concluded that however rich, powerful, and lauded such a man may be, he will "go down to the vile dust, from whence he sprung, unwept, unhonoured, and unsung."

Nathan Hale gave his life for his country and died with a blessing on his lips.

William Joyce's last words are unrecorded.

Various Discoveries

———— ❦ ————

I have sworn off the news because there is nothing new, and reiteration of the well-known and unfortunate serves no purpose other than as the bad narcotic of despair.

But I traded cars, which cheered me up. My new car has a satellite radio. Scrolling through the various selections, I came upon Billy Graham, gave him a listen, and continued listening, entranced.

He is the best speaker I have ever heard. His messages of the Gospel are all simple and convincing. He speaks of eternal life, of heaven and hell, as realities. A modern, Western agnostic might discount the belief as a blot on his intellect, but I've seen enough of life to've experienced both heaven and hell on earth.

The Eastern religions teach an afterlife of the *soul* as reincarnation and cleansing of karma. I've seen newborns emerge with a personality and a soul and seen both vanish in the moments of death. I believe in the soul's persistence and would be thrilled to accept the Christian tradition and Christ as my Savior. But I am prohibited from doing so by my own religion, Judaism.

Billy Graham quotes from the Jewish parables of the Old Testament

and from the Jewish parables of the New, for Christ, a rabbi, taught in the Jewish tradition, as do the Chassidic masters—in parables, riddles, and paradox. And, like the Chassids, Billy stresses the immanence of God: "It is not far away, that you should say, 'who can achieve it?'"

The Chassids were and are a mystical, populist sect. Unlike the Jewish mysticism of Kabbalah, which teaches abstruse forms and practices in order to approach the divine, Chassidus is a message of immediate and joyous union.

In the latter days of the Temple there was antagonism between the rabbinic and the priestly classes; between, that is, the scribes and the Pharisees. The Essene rabbi, Jesus, preached a third way, as does Chassidism, and, it seems, Evangelical Christianity. The third way is that of unmediated connection between the individual and God.

Billy Graham loved Christ, but he didn't like Jews.

James Warren wrote in *U.S. News*, recently, recalling a story he'd broken in 2002 on release of a Nixon tape in the National Archives and Records Administration recorded after a Prayer Breakfast in 1972:

> GRAHAM: This stranglehold [of the Jews] has got to be broken or the country's going down the drain.
>
> NIXON: You believe that?
>
> GRAHAM: Yes, sir.
>
> NIXON: So do I. I can't ever say that but I believe it.

Graham and Nixon continued excoriating the Jews and their stranglehold on the media. I direct readers to Mr. Warren's article.

Apologists state, reasonably, that Graham was just a man—that is (and which he would affirm), a sinner. Aren't we all? And the Evangelicals are the best (and prior to the Trump administration the sole remaining) friends in the West of the Jews.

But I found this example of what William F. Buckley called "workaday

anti-Semitism" important because the participants troubled to keep it hidden. They shared it in secret because they knew themselves to be indulging in a shameful pleasure.

Recently I've had addressed to me, for the first time in my life, vile comments about "the Jews," or, as if that were more acceptable, "those Israelis." That anyone could take me for anything other than a Jew surprises me; either the anti-Semites "just couldn't keep it in," or they weren't paying attention. Or, more troubling, that hatred has been so legitimized, by various organizations, political movements, and politicians, that its indulgence need no longer entail shame. The inevitable end of legitimizing hatred is, of course, murder.

But why, if the Jews, who, as Billy Graham and Nixon suggested, "have a stranglehold on the media," did those Jews not speak up for Jews?

Here's why. The bigots mistook an observation for a conclusion. If (as was and is, to a lesser extent, true) a majority of the media are Jews, it does not follow that they must be exercising their influence for "Jewish" benefit.

One might with as little reason say that because most of the mid-century New York transit workers were Irish, they must have determined the subway routes. The Jews (and the non-Jews) are in the media for the money. It's a business.

The House Un-American Activities Committee (1938–1975) ruined lives by searching for Communist propaganda in mid-century entertainment. There was none. Who would have put it there? The studio heads were churning out product in order to put lobster on the table. They were appealing to their understanding of the masses. They weren't selling "social change"; they were selling popcorn.

Not only would no Jew have *made* a film of Jewish propaganda; no Jew would have paid to *see* one. And the Jewish moguls knew it. Jews and non-Jews pay to be entertained. Period.

Ilhan Omar and her supporters spout Jew hatred clothed as anti-imperialism, the State of Israel here being their handy whipping dog. But Jews went to Israel because there was nowhere else for us to go. The

world was divided "into places we couldn't go and places we couldn't stay."* We went into the movie business for the same reason: most professions were denied to us.

But the question occurs to me again: Why are Jews liberals? And I have come to a new answer. I used to think we voted for Democrats out of a millennial biblical occupation with justice, compassion, and generosity. I no longer think so.

J. S. Mill wrote that give a man a choice of two tasks, one that will bring him remuneration if he works at it and the other that will pay him regardless of his effort, he will choose the second, take the free money, and employ his energy seeking additional benefits. We see Mill's observation at work in welfare, unemployment, and other government subsidies. No amount of oversight will keep a recipient from taking the stipend and then finding a way to improve his lot off the books.

Similarly, we Jews have two political choices: conservatism, counseling individual initiative; and liberalism, promoting statism, which is to say passivity and government support. But we Jews do not need help or direction in embracing self-reliance; it's been all we've had for two thousand years. It's our party trick. We've always been on our own.

Liberalism was attractive because it offered Jews something we did *not* have and for which we'd always longed: the promise of inclusion, which is to say anonymity.

An individual and a people get so damned tired of being outsiders.

Rather than being praised for creating wealth in previously unimagined or despised pursuits (entertainment, comic books, family law, the foundation of the Jewish state), we are cursed for our achievements.†

But if the promise of liberalism were true, if all barriers to prejudice could be eradicated through law, why, we'd vote for that and, voting, *pay* for it. And if it meant ignoring anti-Semitism, or the BDS movement,

* Abba Eban, first Israeli representative to the United Nations.

† Note: The accusation, finally, that hard work and initiative are "cheating."

the Squad, *or what we knew of self-sufficiency*, well, that was a small price to pay for retaining our illusions of an eventual brotherhood, which is to say of peace.

My peace, of late, has come from reading the Torah. The incidents therein differ from those of the news only in this: the biblical tales of idolatry, perversion, murder, hatred, duplicity, and treason are written without hatred. They are not exploitative attempts to sell soap powder or political candidates; they are parables about the *human condition*, which, without connection to the divine, is always sin. With thanks to Billy Graham.

FARTHER ALONG; OR, THE ACCIDENT CHAIN

H ow is it that California, with the highest taxes in the nation, is incapable of managing its forests, dealing with homelessness, protecting its streets, educating its young, and, in short, addressing those problems for which its citizens are taxed?

Friedrich Hayek observes that taxes exist to fund those things everyone needs but that no individual can pay for. We all need streetlamps, but no individual can pay to electrify his city. Where did the taxes go, and why have we lost the will to ask the question?*

Here we observe the great wisdom of the Prophet's tongue. I refer

* California has spent, to date (or, in Chicagoan, "cops to"), eighty billion dollars on the train to nowhere, a pie-in-the-sky high-speed rail system supposed to eventually link L.A. and San Francisco. Work was continuing on the 175-mile segment from Bakersfield to Merced,† but Governor Newsom announced the remainder of the project would be abandoned. The train will not bring gifts to the good little children on the other side of the mountain, but it certainly brought gifts to its contractors, their lobbyists, and the friends-of-the-knowing who might have accidentally invested in the thing early and sold out on the rise.
† "From Minsk to Pinsk."

not to Proverbs, or the sayings of Solomon, but to the inseparable conjunction, the Hebrew letter vav.

The inseparable conjunction "vav" may mean "and" or "but," which might both cause and explain the ineradicable Jewish tropism toward ambiguity.

For, in reading the Torah, one does not stop to assign a definitive English meaning to the conjunction, but absorbs two ideas that may be conjoined, opposed, or related in some manner that is a distillation of the two notions. What might that manner be? (Jewish answer, "aha.")

It's said that German humor is about excretion and French humor is about sex. Jewish humor is about ambiguity. We Jews mock not the functions of the body but those of the mind.

A man comes home one day early, from his business trip. His wife is in bed, in the middle of the day. The man shrugs and goes to the closet to hang up his jacket. His best friend is in the closet, hiding, naked. The friend says, "Everybody's got to be somewhere."

It's not surprising that we Jews are obsessed not only with solving the mysteries of cause and effect (see all the Nobel Prizes in Physics) but with enjoying their ambiguities: see fifty-eight hundred recorded years of human trauma, attendant expressions thereof, and explanations and prescriptions making the condition worse.

How did California, with the world's sixth-largest economy and incomparable natural resources and beauty, transform itself into a hellhole? Or must we understand the conjunction here as "therefore" rather than "nonetheless."

Transportation safety folks talk about the accident chain. This is a modern discovery of the old saw "For want of a nail the shoe was lost."

The mother was about to drive her small child to school. She started buckling her into the car seat when she heard the teakettle whistling in the house. She went back into the house to turn off the teakettle. She'd neglected it because, when she was making the tea, the phone rang. When she got off the phone, she was late, and so she rushed her child into the car, forgot she'd left the kettle on, and returned inside to turn it off.

She was driving her toddler to school, the kid started to climb into the front seat because the mother had forgotten to buckle her in. The mother turned around to secure the kid and ran into a tree. Where did the accident chain begin?

Army aviators, returning from World War I, brought back the French affectation of flying with exotic feline cubs as pets. A barnstormer flew with his pet cheetah up front until the creature got too big for his lap, when he transferred it to the rear seat. The cheetah enjoyed flying, because the hum and the vibration put him to sleep. One day the cat, now fully grown, slipped, asleep, off the rear seat and jammed himself against the rear stick; the pilot, up front, thus had *his* stick (linked to the rear) immobilized and flew into the ground.

Why did the pilots fly with exotic cubs?

French law prohibited foreign nationals from service in the French armed forces. Before our entry into the war, Americans who wanted to fly for France were inducted into the French Foreign Legion—a service exempted from restriction.

The legion saw extensive service in Africa, where its officers adopted a taste for exotic pets. Did the barnstormer die because the French colonized much of Africa? Of course/certainly not.

Is it a good idea to destroy midtown Manhattan because America had slavery 160 years ago? Or to promote the California wildfires rather than to "artificially" clear brush and create firebreaks?

Are we humans capable of a logical and moral understanding of the past (history) or a practicable and rational projection of its lessons (economics)?

Here are two supportable views of the accident chain. The gospel song:

"Farther along we'll know more about it
Farther along we'll understand why
Cheer up, my brother, live in the sunshine
We'll understand it all by and by."
And a Jewish response: "Yes, but . . ."

ON THE PASSIVITY OF JEWS

<center>⸙</center>

Vladimir Jabotinsky was one of the founders of the Jewish state. He was a Russian Jew living in England. He enlisted as a private in the British army during World War I and took it upon himself to negotiate, with the British government, to allow Russian immigrant Jews to fight in the British army in the Middle East, known then as Palestine. He succeeded in getting a special but limited dispensation: they would not be allowed to fight, but could be enlisted as mule drivers. They were formed into the Zion Mule Corps, under the direction of Colonel John Henry Patterson, fought at Gallipoli, and, reconstituted as the Jewish Legion, were, it seems, responsible for most of the victories attributed to Lawrence in the dime-novel journalism of Lowell Thomas.*

Jabotinsky was the colleague of Joseph Trumpeldor, an ex-colonel of

* A similar instance in American history. The first Black regiment in the American army since the Civil War was the 761st Tank (formed 1942). Black servicemen, considered unequal to combat, were enlisted as drivers. They were later put in the line, as combat soldiers, tank commanders, and crew, in the Battle of the Bulge, and served with great distinction. See G. F. Borden's magnificent novel *Seven Six One* (1991).

the tsarist army. Trumpeldor was the first Zionist to advocate and *practice* self-defense as an inalienable right. He, a Jew, rose to high rank in an anti-Semitic army through determination and strength, and he quite simply *did not understand* how his fellow Jews hoped to thrive in a hostile world without these qualities. Jabotinsky was his protégé. Trumpeldor said, "You can take the Jew out of exile, but you can't take the exile out of the Jew."

We Jews, individually, are human beings capable of heroism, but as a group we are trained, first and most important, to escape notice. For notice has, for thousands of years, equaled death. I exempt not only the Jews of Israel but the Orthodox communities of the diaspora. And now my exemptions are complete.

I was stunned, last year, to see a television commercial proclaiming the universal appeal of its product. There were happy young and old, Black and white, straight and gay, and, *mirabile dictu*, a young Jewish couple, identifiable by the man's yarmulke.

Who had seen the like before? Not I.

Were Jews, in violation of all historical norms, being recognized as human beings? No, we were being appealed to as consumers.

Here was Adam Smith's invisible hand at its least deniable. For one could argue free market economies, and produce or confect disprobative statistics, but here it was in practice.

The free market is the practice of self-betterment through trade. Adam Smith's beneficent invisible hand was operating here. For the aim of the ad was not to improve the lot of the Jews but to enlarge the market of the purveyors. But the *effect* of the ad would be the former because, whether or not more widgets were sold, the *desire* to sell more would change the perception of the populace. Just as it had with the depiction of Blacks, Asians, and gays. The outreach to a broader consumer base was recognizing a marginalized populace not as human beings but as *consumers* and backing up that recognition with good hard cash spent on advertising.

Newspapers have, very recently, ceased identifying individual Blacks by the addition of the modifier. White men were, previously, "men"; Black men were "Black men."

I believe the newspapers changed as an act of conscience. But conscience was never at work in the ad industry. The "socially conscious" adjectives "fair-trade, free-trade, cruelty-free" exist only to entice, replacing the more ancient but no less factitious "new" and "improved."

The TV ad's depiction of religious Jews might have done more for Jewish pride than Exodus, *The Diary of Anne Frank*, Camp David, Oslo, and all the good-willed, sententious, and destructive offers of "tolerance." These offers, of course, can only come from those both parties agree are the superiors. Absent the agreement of those so addressed, offers of "tolerance" are, of course, insults.

One might insult a political fool, and one might attempt to hoodwink, but who would insult a potential buyer?

Now, if you cut us we do bleed, and if you tickle us we do laugh, but, with apologies to the Bard, if you wronged us, historically, we would not revenge. We could not. We also differ from Shylock's assertion of humanity in this: asked, "If flattered, do we not smile?" one might respond, "Who would flatter us?"

After the fall of Jerusalem, and to this day, *no* one flatters the Jews. One may be awarded status as an *individual only*. Early years had this or that Jewish celebrity signaled out as a credit to his race, but this meant only "in *spite* of his race." If you flattered us, would we not lie down and request you to scratch our belly and submit to your blandishments? We were never put to the test. But, like many another unbalanced organism, we availed ourselves of imaginary benefits.

The timorous nonentity knows himself chosen as he begins to hear voices from Mars.

We Jews discovered self-flattery in the era of civil rights. Prior to the

postwar prosperity of the Ashkenazi immigrants, we devoted our energy to piecework, study, wonder at the blessed absence of Cossacks, and acute listening for their no doubt imminent arrival.

Now, after the Depression, back from the war, graduated from college, and beginning in the professions, we had energy and leisure to expend, and spent them not only on entertainment but on the delighted exercise of status. Still too poor for philanthropy, we found benevolence within our reach.

But to whom could we feel superior?

Enter the NAACP.

I know nothing about it but its name and its professed aim: the betterment of Black Americans.

I'm writing only of the reaction of my parents' generation of Jews.

They were supporters of (donors to) the NAACP. I don't know how this advanced the cause of human rights for Black Americans, but I am sure it did not hurt.

The Jews of my parents' group were one generation from the Torah study of eastern Europe. They grew up reading and hearing the most often repeated of God's admonitions: I am the Lord your God who took you out of the land of Egypt, out of the House of Bondage; Be kind to the slave, as you were once slaves yourself; You must *not* return a runaway slave to his master; and so on.

This admonition was, and is, the big gun of God's arsenal. (See "I took you back after I discovered you boffing the maid.") We Jews were schooled in justice (which is to say making difficult decisions based upon divine law) before it became "social justice" (that is, "following your feelings because they, belonging to a superior being, will always be right").

So I will not discount my parents' wish to pursue justice, nor the wisdom nor efficacy of donating to the NAACP. But there was another element in their support. It was pity.

My parents, just removed from the Black Hundreds, the Cossacks, the death camps and pogroms, pitied the Blacks for the color of their skin. The Jews found the physical fact of skin color unfortunate because

it deprived Blacks of the one benefit the Jews believed we possessed: the ability to pass.

We could not and *can* not pass. The world susses out the Jew, however prettified or acculturated, with the same immediacy with which the Jew identifies the Christian. To ensure his identification is complete, the Jew will *confess*. Even today, this or that assimilationist, leftist, and so on will, criticizing Israel, addend "and I'm a *Jew*." But the Jew believed the Blacks worthy of pity, if not compassion, because they were doomed by their skin color.

It was not that they were an inferior race but that they were through no fault of their own to be always subject to the whims of racists. While we Jews, we thought, were not, and the Blacks afforded us a (factitious) proof of our assertion.

Jews didn't wish ill for the Blacks, but identifying assimilation as the summum bonum, we wished ill upon ourselves. Rather than delighting in the culture and society of our own people, we opted for the promise of assimilation, thus rejecting the only possible conjunction providing protection.

Assimilationist Jews ran here and there, loathing the only president who treated them as human beings. They said, "He is being unfair to the Palestinians," but they *meant*, "He is making it hard on the rest of us."

BRUNO BETTELHEIM
AND THE BROKE-DOWN COWBOY:
TWO AMERICAN STORIES

B runo Bettelheim (1903–1990) survived Auschwitz and came to America. He fetched up in Chicago and proclaimed himself a psychiatrist, becoming Dr. Bettelheim. He was neither a psychiatrist nor a doctor and had, it seems, completed only a bit of a German university course in art history. So far so good. Then he announced himself the one fellow who could cure autism.

Autism is a group of symptoms and behaviors first recognized, or collated, in 1911 by Eugen Bleuler, a Swiss psychiatrist. Prior to Dr. Bleuler, children considered unreachable, preverbal, obsessive, compulsive, withdrawn, and so on were known as retarded, moronic, or stupid. They were treated, as incurables, with varying degrees of kindness, support, and care, or sequestered, abandoned, or beaten, depending on the morality, compassion, resources, and patience of the caregivers. It is said that if one knows one autistic child, one knows one autistic child, for they are all different. The sub-diagnosis of Asperger's syndrome was in vogue in the years 1981–2013. The constellation of behaviors it described have now been reclassified as high-functioning autism.

Autism is the polar opposite of a lot of fun. My godson is an autistic child, and his parents' efforts to help him have, I am sure, benefited a construction industry called upon, thus, to create ever more pillars and posts to which they could run. As Tolstoy said, when many remedies are proposed for a disease, it means the disease is incurable. The heartbreak of an autistic child may be observed by many but may be understood only by his parents.

So "Dr." Bettelheim hung up his shingle in Chicago and founded an autistic cure outfit called the Orthogenic School. His rule No. 1: patients' parents were prohibited from "interfering" with treatment. They had to leave their child to the custodial ministry of Bettelheim and the Orthogenic School. What parent would agree? you may ask. I'll tell you: the desperate and the guilty.

Why would anyone be guilty? Bettelheim proclaimed that autism was caused by bad mothering. Mothers, he said, had ruined their children, and so must be denied contact. The parents delivered the children to the school and were instructed to stay away.

Well, a parent with an autistic kid will do *anything* to seek help. There's no solution too absurd to be embraced, for they *are* guilty that they are unable to help their child, and guilt (offering the illusion of *explanation*) was preferable to despair.

So the mothers were blamed and, indeed, sent by Bettelheim to "mothering" courses. What was he doing to the children sequestered in his facility? He was beating them. The mothers began finally, and against his injunctions, to share information and to refer to him as Benno Brutalheim.

He wrote many very readable books (we may note he was accused, on more than one occasion, of that degree of authorial "borrowing" that goes under a more severe name). One of his books was influential in my writing. It is *The Uses of Enchantment* (1976), for which he won the National Book Award and which *The Journal of American Folklore* claims restated the work of the psychiatrist Julius Heuscher's *Psychiatric Study of Myths and Fairy Tales* (1974).

I must read Heuscher and, having done so, will most probably recommend it to the interested, along with the only works I have found helpful in writing drama: Aristotle's *Poetics*; Campbell's *Hero with a Thousand Faces*; Opie's *Lore and Language of Schoolchildren*; and, be it what it may, *The Uses of Enchantment*.

For, from whomever the insight sprang, it was, to me, a stunning insight that one *must* not characterize the hero; that, as in a fairy tale, we are told only a handsome prince, or princess . . . and are thus inspired, unconsciously, to realize ourselves as such.

Each characterization of the hero (young, old, Black, white, blond, brunet, and so on) that does not jibe with our self-image takes us out of the story. An invaluable understanding for the storyteller.

And I've had occasion, of late, to recall another of Bettelheim's insights.

He wrote of the brilliance of the Nazi salute under Fascism. All were forced to give the salute. Many did it out of fealty, some as a mere convention, but many found the Nazis an obscenity. They nevertheless were, at first, risking and, later, forfeiting their lives for the failure to give the salute. They were forced to give the salute hundreds of times a day.

Bettelheim observes that the human mind cannot stand the constant performance of hypocrisy, which is to say of self-indictment. One could not remind oneself, throughout the day, "I'm giving the salute as I *must*, but I abhor that which it represents."

The salute is first performed with a mental reserve; constant repetition requires performance *without* the drudgery of reservation; the salute now becomes an automatic response. But see the psyche's capacity for accommodation: not only is the salute now performed automatically; it is *attended* by the individual's (unconscious but *quite real*) gratitude for the alleviation of the previous mental struggle. This gratitude, because it occurs when the salute is given, is associated (again unconsciously) with that entity to which the salute is performed. The person has thus become a Nazi sympathizer, which is to say a Nazi.

Now we saw Americans cowering before anyone not wearing a mask.

We saw our fellow citizens riding in closed cars wearing masks. *The New England Journal of Medicine** wrote that masks used in public spaces are largely both useless and pointless, because the virus cannot be transmitted except through close contact with one who *has* the virus.

Folks in my neighborhood crossed the street and scowled, and some screamed, at their unmasked neighbors. I was, like Bettelheim's anti-Nazis, forced, a hundred times a day, to reassess my position in the community, my loathing of my neighbors' stupidity, and the nature of a microbe. I was depleted by this constant cost-benefit analysis and unable to abandon it.

I dragged my wife all over the map looking for somewhere in which we might live with a reasonable promise of peace. Here are two observations from these various trips:

A family of four, on mountain bikes, at five thousand feet, climbing an empty road in northern Nevada, all four wearing masks.

And a broke-down cowboy.

We'd left the once thriving Santa Monica Airport, which the city council has turned into a ghost town. We flew to Scottsdale Airport, which is awash with planes, money, employment, commerce, and all the attendant benefits of prosperity.

Prosperity, the Left screams, creates inequality, and indeed it does; another name for inequality being prosperity. And there we were in the Scottsdale FBO, which is a service outlet for private aviation. The place was spotless, stocked with amenities, and run by eager and helpful folk.

* "We know that wearing a mask outside health care facilities offers little, if any, protection from infection. Public health authorities define a significant exposure to COVID-19 as face-to-face contact within 6 feet with a patient with symptomatic COVID-19 that is sustained for at least a few minutes (and some say more than 10 minutes or even 30 minutes). The chance of catching COVID-19 from a passing interaction in a public space is therefore minimal. In many cases, the desire for widespread masking is a reflexive reaction to anxiety over the pandemic." *The New England Journal of Medicine*, "Universal Masking in Hospitals in the COVID-19 Era," May 21, 2020.

"Well, yes," I said to myself, "good for you, young people, who have not been robbed of the ambition to do well, and, thus, to do better."

And there at the chrome and Naugahyde coffee table was a broke-down old cowboy. He appeared to be in his nineties. He wore a beat-up, ancient straw Stetson, a washed-out work shirt, jeans so old as to be almost transparent, and dirty work boots.

He went to the counter to talk with an employee. He was bowlegged and hobbled. We were looking at an actual old cowboy: he'd spent his life on a horse and had, most probably, fought in World War II. I loved the sight of him.

My wife saw him stumping back to his seat and shook her head in sympathy.

"Who is that guy?" I asked.

"I don't know," she said. "Tell me about him."

"*That* guy," I said, "is our last view of the American West. He worked all his life, in cattle or oil, came up from nothing, and made a pile of money."

"He looks like a derelict," she said. "He's wealthy?"

"He ain't wealthy," I said. "He's *rich*. He's sitting here waiting for his pilot to pick him up in a forty-, fifty-million-dollar airplane."

"But why would he dress like that?" she asked.

"Because those are his clothes," I said. "Ancient wisdom from the stockyards: the rich guys aren't the ones in the fancy hats; they're the fellows with shit on their boots."

The early Soviets dispatching their intellectuals to trade delegations in the West issued them rough, thick dowel rods, on which they were to rub their hands, creating calluses.

How can a country survive whose electorate has never seen a man, except their gardener, with dirty hands? It cannot.

ATTENTION MUST BE PAID

I am thinking of my father quite a bit lately. He grew up on the West Side of Chicago, raised poor, by a single, immigrant mother, in the Depression. He enlisted right after Pearl Harbor and served in the army in World War II. After the war, he bluffed his way, under the Jewish quota, into Northwestern Law School and graduated first in his class. He then spent forty years as a labor lawyer, representing the film technicians' union, the Building Trades Unions, and a lot of other workers.

I broke out of, or was excused from, the middle-class existence he'd achieved for his kids, and I knocked about, making my living at what would now be called entry-level but then known as menial jobs. I became fascinated by the speech of the people I met and worked with or for and with that of those among whom I spent most of my leisure. For I was a snakebit gambler, and my off-hours passed in backroom poker games.

To me, it was as it must have been to white musicians in Chicago in the 1920s, hearing jazz for the first time. A Chicagoan locution: "Yeah, I was crossing the street, and if I didn't look twice, I would of got hitten by a cab." And the oddity in the speech I heard was the occasional *absence*

of profanity. I took it all in, and I wrote it all down because it was alive, and I loved it.

Part of the Left's outrage at Trump was his refusal to speak in hieratic language.* He's spent his life buying and selling politicians, negotiating with construction unions, bureaucrats, and The Boys. He speaks American, and those of us who also love the language are awed and delighted to hear it from an elected official.

As for profanity, what is its linguistic purpose? For on various streets and in various jobs it is expected and in the military required.

See S. I. Hayakawa's *Language in Thought and Action* (1949): A fellow from Oxford comes down to the British coal country to campaign among the miners for electoral reform. Miner says, "Hey, what's all this bloody nonsense about 'one man, one vote'?"

Oxford chap says, "Why, quite simply, it means 'one bloody man, one bloody vote.'"

Miner says, "Then why the hell can't they just say so?"

I spent many blessed years in a village in Vermont. The village custom held that all males, from boyhood, had a nickname and that it followed them through life. I recall Chunk, Bozo, Nooky, Spud, Buggy. The names could be called across a field or a shop floor. They had good consonants. A good dog name, similarly, should be able to carry. One might call a working dog Buck, or Queenie, but not Leslie, or Thea.

The hard consonants get the attention, which is one purpose of profanity. As in "one bloody man, one bloody vote"; it is used generally as the direct object indicator. It is, of course, also an expletive. See "those two words which introduce every airborne emergency," but even in the wish

* It is the immemorial tactic of a dictatorial regime to accuse its opponents of what it is doing. Donald Trump was vilified by the Left because "he lied"; in fact, he was at a disadvantage because he did not lie. He was, by inclination and experience, a superb director—that is, one who achieves a goal through inspiring employees—but he had neither the inclination nor experience to rule, which is to control disparate groups through false promises, stealth, deception, propaganda, and lies. It's all there in *The Prince*. We don't know if today's thugs have read it, but we may be sure Marx did.

for various powers to do "some things to some people," profanity, as the direct object indicator, is linguistically useful because it means "stand by."

Biblical Hebrew is a punchy language. It largely dispenses with pronouns, attaching them to the verb or noun; it also features the direct object indicator—for example, "He sent ET the messenger to the river" (ET being the indication that the direct object is coming up)—and so one might do well to pay attention.

In demotic Chicagoan that speech particle exists as "He sent the #$% messenger." The direct object indicator—same thing. How lucky am I that my grotesque career as a student debarred me from the study of philology, deconstruction, the search for a universal grammar, and the attendant wisdom of Noam Chomsky.

No, I, an apikoros (Hebrew: "apostate," from "epicurean"), have always been fascinated by actual speech. Why, for example, does one say "a history" but "an historical novel"? A mystery.

But I heard my father use profanity only once, and I've thought about it quite a lot of late. The world, through the rough treatment of which he'd lived all his life, was in the midst of its usual absurd upheaval; the then current rendition: the Vietnam War, assassinations, the Cuban missile crisis. I asked him if he had any wisdom. And he said, "Sometimes the world's just got to take a big #$%&." Rough and unlovely speech, but like the direct object indicator, it served to get my attention.

Language, of course, is generally employed by human beings to distract or deceive. So there is much to be said for critical listening.

Take, for example, the language of crickets. One may count their chirps in fifteen seconds and add thirty-seven. The total will approximate the temperature in Fahrenheit. All honor to whoever first listened and figured it out.

Years ago a then-revered talk-show host, a man of wisdom, humor, and probity, peppered his show with ads. He introduced most of the ads with the words "My friends." He used the phrase nowhere else. A close listener might observe that he was trying (consciously or not) either to lull the listeners into receptivity or to excuse to himself his (no doubt

necessary) descent into the permitted approximations to truth of the marketplace.

My grandfather Jack emigrated here from Warsaw. He was a dour man and had only one joke. Here it is: "What do you have to pay to go to school?" Answer: "You have to pay attention."

In the film the great and powerful Oz is revealed as an illusion, manipulated by the Wizard, Frank Morgan, a huckster pushing buttons. He employs the sole possible defense to his unmasking: "Pay no attention to the man behind the curtain."

I will leave the conclusion of the simile to the reader.

EXPERTS AND OLIGARCHS

C on men and magicians know that the more intelligent one is, the easier he is to dupe.

These know that the difficulty in getting over on a mark is not to awaken his greed (who among us is not greedy?) but to bypass his suspicions. How is this done? By appeal to his intelligence.

Count Victor Lustig (1890–1947) won the confidence of the very canny Al Capone thus: He approached Capone, promising to double his money in six months. He asked for thirty thousand dollars, and Capone gave it to him. Capone asked Lustig for no security, because the cost of failure or theft was known to both.

Lustig returned to Capone in six months and confessed failure. "It just didn't work out," he said. Capone scowled. Lustig continued, "Here's your thirty thousand back." After this, of course, Lustig had not only Capone's ear but his trust, to do with as he thought prudent.

A wealthy, powerful individual must expand his operations; for, even should he let the capital sit, he will need accountants, auditors, stockbrokers, and advisers. How will he choose them? According to the opinions of other advisers.

Those close to the throne will have great power and can keep it even in success, only coupled with flattery and deference. The powerful, however, do not happily brook superiority in anyone, their patience in inverse proportion to their power.

It's said if one is rich, one can tell a funny story and sing. The wealthy man even enjoys a sense of engineering "intuition" in the presence of the would-be-successful architect.

The latter is a supposed upper servant graced by his employer's camaraderie. He may or may not build the building he wished to build prior to his patron's idiot meddling, but he will assuredly take his opponent to the cleaners, let the building be what it will.

The canny businessman is offered the choice between paying the architect by the hour or on a cost-plus basis. Whichever he elects will prove, at the close of play, to be more costly than he had supposed; he may bemoan his choice, but had he made the other choice, *that* would have proved, surprisingly, more costly than supposed. Or he may be so wealthy that he does not care about the cost.

This last is the case with governmental power. We are all fools off our home turf, and no one person can know everything. We have to trust others for their expertise, and we all make mistakes. The horror of a command economy is not that mistakes will be made but that they will not be corrected.

Who, in government, will suffer from destroying our economy? No doubt, it was done in good faith; however, it is the job of the politician to amass power, and should he discover that that power may come, for example, from draconian measures in the name of health, the measures will continue until he perceives more wealth or power in their elimination.

Who had seen such a fraud before? Anyone who lived through the Great Depression.

In 1929 the stock market cratered. Roosevelt was elected in 1932, at the height of the Depression. He, who'd never had a job, decided he would take charge of the economy. He instituted absolute wage-price controls (the National Industrial Recovery Act, 1933–1935) and turned

a bad month on Wall Street, in the most prosperous economy in history, into a decade-long worldwide depression.

He rose each morning to his cup of coffee and his cigarette and *decided* what the price of gold would be that day. Like the solons of today, *he* was not out of a job. He was playing cowboys with the economy and invited his "Brains Trust" to play along with him.

We need not imagine (because history records) how they cut their opinion to flatter the boss, as Americans starved.

The Prof, Professor Frederick Lindemann, was Churchill's adviser on all things. The Prof was Jilly to Churchill's Frank Sinatra. No experts were allowed to the throne, lest they come through him. He feuded with all and was especially irked with Sir Henry Tizard, one of the developers of radar, a device whose utility Lindemann originally mocked.

Lindemann also used "scientific evidence" to dismiss the possibility that the Germans were developing a liquid-fueled rocket capable of bombing London (the V-2).

Stalin's science adviser was Trofim Lysenko. He was an exponent of science as politics and, as such, had complete access to the throne. Like the blank slate, his theory was that plants, like good Communists, could be educated, that peas and wheat could be *trained* to grow in winter. Under the direction of his Ministry of Agriculture, seven to ten million died of starvation.

And now we have the "science" of global warming, and news, education, and opinion warped to support an un-demonstrable opinion; dissent is indicted and, where possible, banned as the production of monsters who, by their acts, are self-confessed as the enemies of humanity.

And now we have had COVID-19.

And an epidemic or pandemic was allowed to destroy the American economy; tens of millions were driven out of work, covered their faces, and cowered in the streets in fear of their neighbors.

A friend owns a restaurant. He was going broke. He had seating outside, but it was growing cold, and heaters were back-ordered until next Shavuos.

But he was holding on. One was "permitted" to sit at his tables and eat without a mask. Indeed, how would one eat while wearing one? Does the virus know that one is sitting down?

He greeted two regular customers one night and sat at their table to chat. He took off his mask. The customers informed him that the regulations stated that employees of a restaurant are required by law to wear masks *at all times*.

He thanked them, put his mask on, and rose.

But does the virus know he is an employee of the restaurant? With whom would he argue being an employee or a proprietor? With the virus?

The virus, here, is government. Absent intervention it will, like any disease, eventually kill the host organism. The problem is not that the electorate may choose badly, but absolute power will not admit of any change at all. Churchill, Roosevelt, Stalin, and today's Left are like the inspired amateur architect; they cannot admit of the *possibility* of dissension and so will not abide the proximity of anyone who might admit it, the Electoral College included, and the electorate is free to kick the cat, starve, or "tell it to the padre."

When weakened, the body politic, like the physical body, is subject to opportunistic infections. Four years of anti-Trump hysteria, race-baiting, engineered economic disaster, and riots subjected the American body politic to threats (to the Constitution, to religion, to reason) a healthy organism might have shrugged off.

Parasites derive their life from the host organism, which, unchecked, they will eventually kill. This is the avowed historic mission of Marxism, but, the body dead, the parasites, feeding upon live growth, are replaced by saprophages. These live off dead and rotten flesh.

SLAVE LESSONS

In the Chicago of my youth we were not shocked by corruption. We might have been stunned by its absence, but we never encountered it.

Mayor Richard J. Daley presided over the city council meetings, and when any members spoke in opposition, he shut off their microphones. The cops shook down the cabdrivers; the fire inspectors battened on the restaurant owners. In any difficulty with city government, the question was not "Who is right?" but "Who do I got to see?"

It was understood that taxes built the beach homes of the elected officials, and anyone who wished actual city services had to kick back in money, favors, or getting out the vote. The model has now been adopted on a national scale.

Now, an active Republican Party might have kept Chicago and the state in some sort of balance, but the Republicans lived in the northern suburbs, outside Chicago, and Chicago was as little a "city in Illinois" as is Manhattan one in New York state.

I am not from the Midwest. I am from Chicago. The Midwest meant the unknown geography to the city's south, the site of farms and of the prison system that would, regularly, accommodate former governors.

Chicago was a machine town and a Mob town, the two entities early practitioners of that thuggery known today as intersectionality.

See New York's Tammany Hall, the K.C. Pendergast machine, Daley's Chicago. The principles sit down, shut up, and see the captain, which ruled the collection of garbage and snow removal, have now been adopted as national policy. Today one keeps the voters ignorant through co-opting the press, but back in the age of the "smoke-filled room" it was unnecessary to put the press to the trouble. Everyone knew what was going on.

The postwar generations are removed not only from the happy knees and elbows of the streets but, increasingly, from its more ordered simulacrum: making a living.

Current liberals, just like the captive Chicagoans of old, are rewarded for their complicity. The Old Chicagoans, however, realized that they received a job on the parks commission, a turkey for Christmas, or immunity from a beating; the rewards of compliance were clear. Until recently, liberals were paid with flattery. They shared with each other the peace and joy of being chosen. But as benefits of this delight waned, Jesse Jackson, Saul Alinsky, Al Sharpton, Barack Obama, and other race hustlers confected a new treat.*

The problem was called white guilt. Torn jeans, body piercings, and tattoos are the attempts of the bored well-to-do to imagine themselves as street creatures. And white guilt offered white liberals the thrill of an enjoyable sadomasochism—just like body piercing.

Shelby Steele has brilliantly named and explained the phenomenon as the equation White Guilt = Black Power.

Race hustlers gained power through indictment ("All white people have racism in their DNA"). Barack Obama said, "The legacy of slavery, Jim Crow, discrimination in almost every institution of our lives.

* What do Listerine and Freud have in common? Both offered a solution to a problem they invented. As did the race hustlers.

You know, that casts a long shadow, and that's still part of our DNA that's passed on. We're not cured of it." Guilt, that is, is racially inheritable. And liberals nodded at the monstrous assertion: that one race was thus *genetically inferior*. What did white liberals *gain*? The same thing they gained in dressing like the homeless: the sick fantasy of victimhood.

White guilt awarded another battle star to their superiority ribbon, for how might one feel guilty about abuse of power if one did not *have* power?

And so, like King Lear, the liberal Left "decided" to grant "some" of the power they supposedly had to "more worthy" recipients—that is, those from whom it had supposedly been stolen.

But, again as with Lear, we see that the generous assignment of *some* of one's power inevitably inspires its recipients to usurp the rest. Hitler ran a bluff on France in 1940, and the Bolsheviks could have been stopped in the suburbs of Moscow by a squad of police (see Minneapolis). King Lear thought himself generous and was beggared by those to whom he bequeathed his power.

Now our country is being eviscerated by the Marxist Left. Each battle they win emboldens them to escalate their activities: shaming becomes blacklisting; picketing becomes destruction; demonstrations become riots. Just as with taxes, all they want is all we got, and who could stop them? Enter Donald Trump.

He looked at the Left and informed us that he knew them of old: they were the same thugs, thieves, cheats, and whores with whom he'd been doing business all his life. He was formed by the construction industry.

The Left wet the bed.

Now a more potent threat was needed to keep the ignorant placid.

Racism was all well and good, and a proven winner, but liberal voters were growing satiated. There are, it seems, only so many times a day and so many years of days in which one can accuse oneself of racism. Eventually the hair shirt, if I may, wears smooth.

Lucky Strike increased its sales during World War II by changing

the package color from green to white and announcing, "Lucky Strike GREEN has gone to war: the dyes used in our previous packaging are required for military fabrics."

Brilliant.

The Left, the universities, and the craven press announced that no *longer* would whites need to consider themselves racist; they could now transfer all that sin upon the head of one man and trade the thrill of self-flagellation for that of unbridled loathing.

But in 2020 seventy-four million Americans had had enough. The joke had lost not only its savor but its *mystery*.[*]

Leftist identity groups now merge, now compete for power, united, finally, in a codependent submission to a lie. That is, that America is an evil land, but even the foolish Left wants to earn a living, and drive a car, and so lives in state-sponsored denial. This enervating state can be sustained only if there is no possibility of individual apostasy, which is to say of freedom.

Supposedly rational liberals assert that there is a "pendulum," and it swings now this way, now that, but that it eventually rests in the middle, because human beings are, finally, rational creatures.

But a walk on our cities' streets will prove we are not. Our populace was terrified into compliance with the governmental cancellation of our economy and, in the works, of free speech, which is to say the ability to communicate our doubts and search for support and direction in community.

Andrew Cuomo endorsed removal of Theodore Roosevelt's statue from the front of New York's American Museum of Natural History. He explained he did it because "they want it," but he did not explain who "they" were. He did not need to. "They" were anyone who would keep him in power.

[*] The electorate that voted for Donald Trump is enjoying the blessed antidote to dejection, anger, and fear: it is clarity.

The opposite of freedom under the law is not "a rational submission to the will of the people" but slavery; and the dutifully masked citizens convinced they were acting for their own safety and the public good were learning to stand in line and do only those things and in that manner which the government allows. They were taking slave lessons.

What is the irresistible tropism which instructs that display of last year's essential fashion is, this year, a sign of lunacy? How is the information transmitted? We consider it clownish to dress in outlandish styles we once adored, and a clear invitation to scorn. Adopting this as a baseline, we, herd creatures, find unpopular ideas dangerous and, unwilling to accuse ourselves of temerity, name their mere rejection courage— but a courage that can only be awarded *as a member of the group*, by which we may observe that it cannot be courage at all.

Belinda Raguesto
Returns from Switzerland

F ilm executives, in their multitudes, are the inevitable dross of any successful endeavor. With too much cash on hand, the progenitors of the successful business imagine the ability to delegate drudgery while retaining control. They hire experts who hire experts, but they can delegate neither inspiration nor final authority, but only the power to say no. This, in fact, is a good definition of a film executive: one who lacks the power to say yes.

No movie was ever made out of "the development process." Films have always been made because someone with power bet on someone with promise.

Since the hegemony of the studios (whether MGM or Netflix), the person in power has usually been an ennobled bureaucrat. In any case, he or she, like any hegemon, at some point, finds it good to enjoy the perquisites of power by gathering loyal underlings, or "henchpersons."

But each loyal underling, of course, develops his or her own agenda. They saw they could most easily gain power from *not* making films, insisting on more funds to explore, to research, or to "reach out" to women,

gays, African Americans, the disadvantaged—in short, they made the perennially new discovery of the power of passivity, of "the committee"; here, that making films carried the risk of failure while "developing" them did not.

Everybody happy, well, I should say.

Now, as one actually involved in making films, as writer or director, I came up, through long years, against a raft of studio executives and had lunch with them all and the horse in on which they rode.

I gained considerable weight but realized that *no* deal was ever closed at lunch. Why? The great (the decision makers) were not going to devote a lunch hour to the company of stoop workers (writers).

No, the great do not lunch with their gardeners, however beautiful the azaleas.

Yes, but why, I, a fresh young thing, wondered, were the lunching studio executives, *even so*, such fools, as they, time after time, shelved my efforts?* Did they not *see*, could they not *read* the script I was offering (a masterpiece)?

Answer: no, they could not, because that was not their job.

I always thought that they lacked imagination. But, no, they, like you and me, are full of imagination; we all spend our days dreaming and scheming, of wealth, revenge, glory, love, and so on. That's why we have movies, to let somebody *else* carry the weight for two hours.

The executives, being human and full of desires both wicked and inevitable, possessed imagination. But even *should* they find it in them-selves to imagine success through supporting scripts that might bring happiness to many and wealth to some, they were restrained from the step by a lack of *understanding*. They did not know how to *read* a script.

Nobody in Hollywood, save some directors, has ever known how, and few, in days of yore, and probably fewer today, even bother. A film

* In thirty-five years in the movie business, I wrote twenty-five or so scripts that were produced and an equal number that were not. One might, with reason, riposte, "Then what is he bitching about?"; to which I respond, "I do it for a living."

is green-lighted on the basis of its cost, cast, subject, and director. The reading of a script is, a brief review will confirm, considered superfluous, as is a script itself.

The script actually exists to describe to the cameraman what to shoot and tell the actors what to say. Everything else is beside the point. No actor ever reads stage directions, and most directors allow the actors to "improvise" (babble), because such is likely more interesting than the written dialogue.

Writers were praised for "writing action" or "writing steamy love scenes," but both of these (essentially identical) treats are always and only made up by the director or stunt coordinator, with no reference to the script at all.

Few have ever understood the nature of a script. It is a recipe. Here are three recipes:

1. An approach plate: it tells a pilot, landing on Runway 27 at Carson City, Nevada, one way to do so.

 A pilot will take it in at a glance, understanding that it is the *simplest way* to describe a procedure, which, when followed, will deliver him to Runway 27. Finally, it means only, "Fly *here*, descend to *this* altitude, then fly *there*." *(See following page.)*

CARSON CITY, NEVADA AL-6515 (FAA) 20310

RNAV (GPS) RWY 27
CARSON (CXP)

WAAS CH 87031 W27A	APP CRS 240°	Rwy Idg 6101 TDZE 4702 Apt Elev 4705

▽ △ NA DME/DME RNP-0.3 NA. Procedure NA at night. When local altimeter setting not received use Reno/Tahoe altimeter setting and increase all MDA 540 feet. Helicopter visibility reduction below 1 SM not authorized. Circling NA north of Rwy 9-27.

MISSED APPROACH: Climbing left turn to 13400 direct JUTBA and on track 162° to MARRI and hold, continue climb-in-hold to 13400.

AWOS-3PT 119.925	NORCAL APP CON 119.2 279.55	CLNC DEL 133.25	UNICOM 123.0 (CTAF) ❶

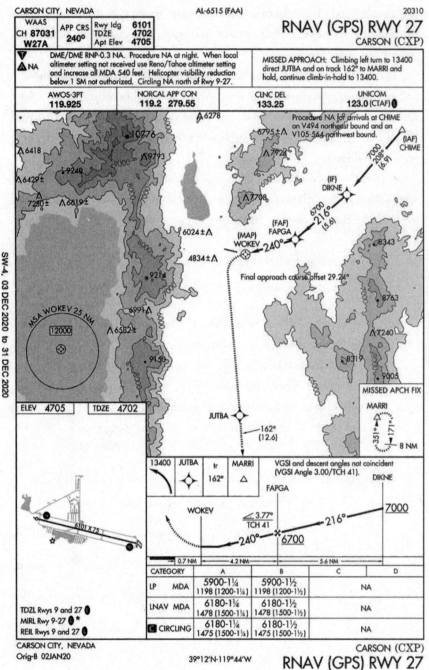

ELEV 4705 TDZE 4702

SW-4, 03 DEC 2020 to 31 DEC 2020

Procedure NA for arrivals at CHIME on V494 northeast bound and on V105-564 northwest bound.

VGSI and descent angles not coincident (VGSI Angle 3.00/TCH 41).

Final approach course offset 29.24°

MSA WOKEV 25 NM 12000

CATEGORY	A	B	C	D
LP MDA	5900-1¼ 1198 (1200-1¼)	5900-1½ 1198 (1200-1½)	NA	
LNAV MDA	6180-1¼ 1478 (1500-1¼)	6180-1½ 1478 (1500-1½)	NA	
Ⓒ CIRCLING	6180-1¼ 1475 (1500-1¼)	6180-1½ 1475 (1500-1½)	NA	

TDZL Rwys 9 and 27 ❶
MIRL Rwy 9-27 ❶ ＊
REIL Rwys 9 and 27 ❶

CARSON CITY, NEVADA
Orig-B 02JAN20 39°12'N-119°44'W

CARSON (CXP)
RNAV (GPS) RWY 27

2. Music in a "fake book," a compilation for a musician asked to play requests.

We note the arrangement has only the treble (the melody) and chord symbols above. No amount of imagination will allow the untutored to play the piece out of a fake book; it requires a modest technical understanding of the cycle of fifths.

The closest the untutored can come to a *mechanical* understanding of a script is its comparison to a recipe, an approach chart, or a fake book. A recipe details the ingredients and the procedures for their combination, which, if followed, would result in the desired product.

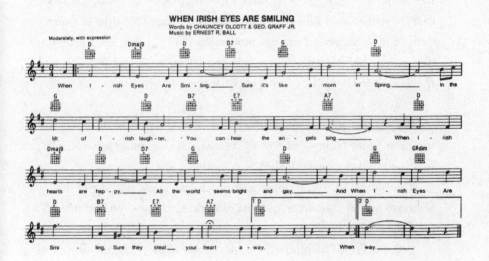

3. A recipe for sponge cake.

SPONGE CAKE

6 eggs	Juice of 1/2 lemon or orange
1 cup sugar	1 cup of flour
Grated rind of 1 lemon or orange	1 tsp baking powder

Separate the whites from the yolks; add a pinch of salt to the whites and place in the refrigerator while the remaining ingredients are being prepared. Beat the yolks and the sugar until light; add the lemon rind and juice, and the flour, which has been sifted three times with the baking powder. Beat the whites until stiff and fold into the batter carefully. Bake in a spring form or in an ungreased pan in a moderate oven (325 degrees) for fifty or sixty minutes. Upon removing the cake from the oven, invert on a wire rack and allow it to cool before removing from the pan.

But it takes an unwonted effort of will on the part of the executive to refrain from taking a bite of the recipe and discarding it because it's supposed to be sponge cake but "it tastes like paper."

The film executive, chained to his rock, can know nothing of the joy of imagining, in the recipe, the majestic dramatic-or-comedic triumph the finished film might be.

But the life of his underlings, the script readers, is not devoid of entertainment, for the scripts that cross their Ikea desks might hold the interest, because they are, in effect, supermarket novels preceded by the magic words "FADE IN."

For example:

FADE IN:

A low warm wind, its warmth preferable to the hot blast that had, until yesterday's weather change, parched this arid plain, brings with it now, at sunset, a desert sweetness, flowing into

the open patio of that ancient hacienda, in the Raguesto family since the days of the Spanish land grants. Allowed to go to ruin in those wars that plagued Texas for one hundred years, it was reconstructed in the 1920s, when Benito, the last of the poor Raguestos, a dying subsistence farmer, struck oil on the land, to which BELINDA, his great-great-great-granddaughter, has now come for the first time—returned from a sheltered upbringing in the convent schools of Switzerland.

She lowers her dressing case to the dry, cracked soil, and looks out over the endless miles, their only relief an odd cactus.

> BELINDA
>
> . . . huh . . .

A viewer, of course, may not film the scent on the wind, nor intuit how today's temperature might have differed from yesterday's, nor that the land was once this or that, and now it is not. Nor know that Belinda is the inheritress. None of it is filmable. It cannot be shot, acted, nor, thus, perceived by any audience.

Why, then, is it part of something called "a screenplay"?

Were it an actual screenplay, it would read like a recipe. Thus:

> **FADE IN:**
>
> EXT. BLEAK BARREN SOUTHWESTERN PLAIN—DAY
>
> A soigné young woman in couturier traveling clothes lowers her posh valise to the ground, and looks around her.
>
> BELINDA
>
> . . . huh . . .

But, the executive says, "I don't get it. Why is she there, what does she want, and what in the world is going to happen next?"

The ability to inculcate those questions in the minds of the audience is, of course, the job of the dramatist. It is the creation of a recipe. When done well, it can pique the interest of the *actual* customer, the viewer, without whose support both the writer and the executives would starve.

Our Constitution is, in essence, a recipe in the form of a contract. The contract is between our citizens and the representatives we elect. It is a recipe for cooperation, to which we citizens can refer, whose contractual terms we can then, theoretically, enforce to bring about the results for which the document was intended: life, liberty, and the pursuit of happiness. It is no more a "living, breathing document" than is the approach plate or the recipe for sponge cake. It is intended as a protection against those who consider themselves wise enough to disregard it, and to protect ourselves against the impulse to credit their wisdom or fear their power—errors we are particularly prone to in times of anxiety.

The lyricist John Burke, in his intro to "Pennies from Heaven," wrote in 1936, a deep Depression year, "No one appreciated a sky that was always blue, and no one congratulated a moon that was always new. So it was planned that they should vanish now and then, and you must pay before you get them back again."

Milton Friedman taught that the dismal science, economics, was, finally, arithmetic, for which work he won the Nobel Prize and for which he deserves the gratitude of all job seekers other than economists.

Should Congress be voted out of its rain dance, it will have been done by those who found it rained wealth only upon those with their feet in the trough.

HAMLET AND OEDIPUS
MEET THE ZOMBIES

Revolutions begin with the mutual discovery of the ideologues and the Jacobins: the first happy to have discovered compatible souls, the second to have found flunkies.

On accession to power, the first become apparatchiks, thrilled with their ability to control events. This brief phase culminates in their murder by their former partners.

The ideologues, in their brief illusion of authority, are happy to invent new names for themselves (Citizen, Comrade) and for every other thing under the sun (his-her-we-they-them); they are let free to run through the big-box store of culture effacing and changing the labels, that is, controlling speech.

The penalty for opposition, as we see, appears almost on the instant. First the expression of opinion is characterized as dissent, then is calumniated, and dissent (now called aggression) is reidentified as lack of active assent.

Those seeking to avoid, first, discord, then censure and the loss of income, quickly find they have nowhere to hide and must choose active endorsement of ideas repulsive to them or blacklisting.

After the inevitable Night of the Long Knives, the threat of blacklisting is upgraded to the certainty of imprisonment or death.

These are the lessons of history, which is to say they are the record of one of the functions of human nature: to guide the individual to power. The urge is checked by the benefits of religion (and so morality) and by those of a constitutional state: the freedom to strive, guaranteed by law and the reasonable fear of punishment for its transgression.

Absent the individual's subscription to these, we have that anarchy which, we see even now, leads to the normalization of crime. What is more delightful to the weak human soul than the prospect of criminal indulgence not only allowed but *endorsed*? Here the human sex trafficking of Epstein Island and the destruction of the cities are the same as Hitler's stunned joy at the taking of France: nobody's going to stop me.

We human beings are a bad lot. Unchecked, we divide into predators and food.

We know the restraints of honor, of morality, of family loyalty, and of the fear of shame and punishment. Civilizations are kept in order (for good or ill) by the carrot and the stick. The Declaration of Independence lists the rewards of life, liberty, and the pursuit of happiness.

But what of the death wish? What of our envy of those better off? What of the urge to amalgamate in search of companionship or camouflage, in fear of the night?

In associations' benign form, we have the sewing circle and the bowling league; progressed into anarchy, we find Occupy, Black Lives Matter, antifa; and then, the carmagnole and the guillotine.

Each knows himself to be weak—to have done evil, or to have evil thoughts and perhaps plans. Mob mentality deals with our self-loathing by blaming it on others: racists, Israelis, "haters." Religion treats unwelcome self-knowledge by offering confession, consolation, and prayer.

Healthy culture addresses the condition with art. Great paintings and music can inspire, suggest, soothe, thrill, *but they cannot teach*. Neither can literature. The arts exist, as does religion, to touch those portions of the human soul *beyond* the corruption of consciousness.

We all know our consciousness is corrupt, and a long life, examined, brings the burden of regret, shame, and indeed a horror at our own actions that, at times, becomes scarcely bearable.

The theater, and tragedy particularly, offers a median between outright confession and conscious, rational (which is to say flawed or at least untrustworthy) understanding.

The tragedy is like the story around the campfire and, just like the joke, frees us from rational consideration. In listening, we are transported into another world. "Once upon a time," just like "there were these two guys," not only reassures but *instantly bypasses* our, necessary, quotidian concerns with our own position, well-being, and self-image.

In hearing these mystic incantations, we relax, because we know the story *is not going to be about ourselves*. Should we suspect, in our unprotected state, that we are actually listening to a cautionary tale (that is to say, to an advertisement), the spell is broken, and we must bring our self-protective capacities to bear.

Here we are like the radio listener, as the host describes the humiliation of some public figure, when he segues, unannounced, into a commercial for internet-image protection and we realize we were hearing an ad.

When we thought we were getting a bedtime story.

The bedtime story exists to address the child's fear of the night and his understanding of his own frailty. He is not called upon to *face it* and to deal with it through *reason* ("There are no such things as monsters"), but he is soothed by a mechanism bypassing his frail consciousness, and his equally frail capacity to be soothed by the same. Which frailty the child shares with us all.

To address his fears by saying, "So remember, never be changed into a wolf," is to make the same error as putting on plays with a "message." These are a terrible misuse of the theatrical moment. As are the "talkbacks," transforming an evening at the theater into an English class.

As free speech disappears like Jimmy Hoffa, producers and theatergoers are left with fear. Not only has a mechanism for relief been

suppressed; the art form has been pressed *into service of the repressive mechanism.*

The theater has long been turning and now, on its (potential) revival, will be found to have turned into the arena for the proclamation of right thinking. The proclamation, that is, of the reign of the goddess Reason, that is, of mob rule.

We have seen, on Broadway, the usual forms of comedy, drama, and tragedy supplanted by the pageant. A pageant is a celebration of human accomplishment, intelligence, grace, or luck—finally of human power over nature or circumstance. It exists to celebrate a person (the birth of Galileo), a place (the founding of Des Moines), or an idea (National Farm Week, the Munich Rally).

It is a perfectly reasonable excuse for a performance and addresses our need for togetherness. But it is the opposite of the drama. Finally, it's just, for good or ill, "the high school play." We attend to applaud the notion presented in the pageant's title. We will not and cannot experience those emotions nor, then, that catharsis for which the theater has always existed. We will not leave the pageant cleansed, calmed, surprised, laughing, weeping, thoughtful, or disturbed. And we will not leave having had the burden of our consciousness momentarily laid aside.

We know that he who rises refreshed from his prayers has had his prayers answered. Our prayers have, similarly, been answered in leaving the magnificent ballet, concert, or indeed football game: our burden had been lifted for a time. The pageant, however, answers not our prayers *but the prayers of others.* They, for good or ill, for whatever reason, civic pride, the hope of gain, the quest for adherents, have staged what is, finally, a demonstration.

The pageant has long supplanted the drama on Broadway, for the reasons following. Seventy-five percent of the Broadway audience are tourists. They come, legitimately, seeking an *experience.* They come to Broadway exactly as they come to Disneyland. As in that happiest place, they do not come to risk their hard-earned cash on a problematic event. (They might not *like* the play nor appreciate being "challenged"; they

might just want a break after a day of shopping.) But no one need doubt that the teacup ride will function as advertised.

The knowledgeable Broadway audience, in the days of Odets, Miller, Williams, et cetera, is long in their graves, and their grandchildren basking in Scottsdale.

The middle-class New Yorkers (and the working class) supported the growth of the American drama. The tourist is not paying to do so, any more than he would pay to go to an amusement park with thought-provoking roller coasters.

Most plays are no damned good. The only way to write a play is to write a *lot* of plays. One learns through putting it on in the garage, in the storefront, off-Broadway, et cetera, trying and failing in front of a paying audience. There is no other way to learn how to write a play.

Off Broadway, off-off-Broadway, are no more. The regional theaters have long devoted themselves to developing a subscribership, "outreach," "social consciousness," and other means of destroying the possibility of attracting actual, ardent audiences.

No one says to his or her spouse, "Look online and see if there are any plays supporting the notion that (FILL IN THE BLANK) are people, too." Or, "Get dressed, because, though you wanted to stay home and have a beer, it is the third Tuesday in the month, and we have to go use our subscription tickets to see some play."

(By the way, what greater pleasure than recognizing, of whatever event, that one is, at the moment, happier at home, and the tickets, whatever they cost, can go hang?)

Finally, to write a good play requires talent. There is not a lot of it around.

It was, I believe, Milton Friedman who, stunningly, said that the free market must exist to entice the able to *reveal* their abilities. If one has no possibility, in the theater, of doing anything but staging platitudes, the talentless will (and do) step up, but the inspired have no reason to do so. The reward of the talented is unfettered creation.

The painter or composer may work in solitude. The creation of the

dramatist is complete only with the addition of an audience. He is writing for *them*. To create, in them, a transformative experience (the laugh, the gasp, dead intent silence, or tears) is the greatest of thrills.

The hack is unaware of the *existence* of talent. He may happily take his pointless facility to producers happy to put on a show of no more actual worth than the monochrome canvases beloved of museum curators.

The New York Times, our newspaper of record, and the liberal media, in conjunction with the schools and colleges, insist that nothing shall be said or staged which does not express "right thinking," that is, statism.

Outreach, education, diversity, and so on are tools of indoctrination. So, for example, are marine boot camp and the Bar Mitzvah. But art is the connection between inspiration and the soul of the observer. This insistence on art as indoctrination is obscenity, denying and *indicting* the possibility of human connection to truths superior to human understanding, that is, to the divine.

A MESSAGE FROM SCHPERSHEVSKI

A Russian Jew, Schpershevski, arrives at Ellis Island. He expects to be met by his brother, now established in America. He's been informed his brother has "Americanized" his name and is now called George Smithson.

He can't find his brother, so he has him paged. The public address is calling for George Smithson, but no one comes forward. Schpershevski now realizes that he is *standing next to* his brother, who is not responding to the page.

"Hold on," Schpershevski says, "they're calling for George Smithson. How come you're not responding?"

"Well," the brother says, "I changed my name. I'm now called Austin Woodford."

"You've changed your name again?" Schpershevski says. "Why did you change your name again?"

"Because when I was called Smithson," the brother says, "everyone asked me, 'What was it before you changed it?'"

Huey Long said in 1933 that it was the easiest thing in the world to create a Fascist organization; all one had to do was call it an anti-Fascist

organization. Planned Parenthood exists to eradicate parenthood; the Inquisition sentenced its victims to torture and death by the allocution "We relax our authority."

Juliet tells us that nothing's in a name, but that was special (and adolescent) pleading.

We know there's power there. See Thornton Wilder's *Our Town*, the best American play. His chorus, the Stage Manager, is speaking about the graves of the Union dead in the New England town cemetery. "All they knew was the name," he says, "the United States of America. The United States of America. And they went and died about it."

Justice is the application of previously decided and accepted norms of conduct and the rules for their examination and dispute. It is as imperfect as any other institution. But a dispassionate, considerate, supportable, and *moral* resolution of differences is the goal toward which it aspires.

Social justice is the negation of that ideal. Here "feelings" are insisted upon as superior to process and order. The iconoclasts claim that justice is too slow, that it is biased, and that it is the right of the individual or whatever groups he may form to express grievances long held, and unheard, in whatever mode he elects.

It is the argument of an abusive parent: "Yes, I hit her, but *you* would have hit her *too*, if you had to put up with the way she behaves."

Social justice means anarchy. But like Planned Parenthood, it has a snappy title, and we are all a sucker for a good line.

See the ACLU, the most absurd bunch of Jews since the Three Stooges. They defend the rights of protesters to riot, of American Nazis to march through communities of Holocaust survivors, of mentally deranged homeless to freeze on the streets of New York, rather than be taken, against their will, to shelter.

The only thing more foolish than one Jew is two Jews.

We were held in check for two thousand years, because we had *no*

inalienable rights. We did not concern ourselves with the state of the world, for our world was limited to getting enough to eat, keeping our wives from the Cossacks, and ourselves from the Nazis, and arguing about the Torah.

This, and the enforced inbreeding of millennia, created a race superb at disputation.

Cut from our chains by American prosperity and the founding of the Jewish state, we became *associate*—that is, to our minds provisional— members of the general population.

We were bred and taught to dispute, but if, as we saw the careers were open to the talents, that no one (in America) was likely going to kill us, and we learned in the elite schools that grudgingly admitted us, God was dead, or a fiction, and the Torah was a fantasy; as we, in sum, assimilated, we kept only the Shabbat candlesticks and the *biological necessity to debate*. At any and every opportunity.

Take the overbred champion borzoi, housed in a Sutton Place triplex all his life. Set him loose on the steppe, and he will scent the wind and lope after a wolf.

We Jews, as a group, are fools. We fell for Marxism, for Freudian analysis, for deconstruction, EST, film school. We fell for Franklin Roosevelt, whose policies returned thousands of Jews to death in the gas chambers, and for Jimmy Carter, to consider whose book *Palestine: Peace Not Apartheid* (2006) as other than anti-Jewish is to adopt the handiest of anti-Semitisms: "I am not opposed to the Jews, only to the State of Israel."

Like the Black community, we Jews have struggled, chopped, and changed, looking for a title that would, to our mind, proclaim how we wish to be treated.

From our beginnings in the New World arrived as "Jews" (an epithet), we have searched for euphemism—each of which was an attempt to distance ourselves from the yet-to-come more wretched refuse following us and endangering our attempts to (pick one or all) assimilate, thrive, escape aggression, or "pass."

A reasonable assessment of the new immigrant American opportunity stunned the Jews and unleashed those energies long devoted only to the Talmud and family bickering. Here, two thousand years of slavery and submission came to our aid. For, like the boll weevil, we had learned that we could thrive *anywhere*, and the only thing that daunted us was good news.

And so, uncertain of any status or benefit, we *always* strove to improve our lot while the improving was good. The loathsome immigrant, a ragged peddler, became, as his lot improved, a pushcart owner, a shopkeeper, the inventor of the department store, of mail order, of ready-to-wear, and the "Jew" became the Israelite, the Hebrew, the gentleman of Hebrew extraction, the Christian Scientist, the Ethical Culturalist, and, since World War II, the liberal. But if one protests one's passivity long enough, eventually someone will come and take him up on it.

"Best Efforts," in a motion picture contract, means, "If you believe this, you deserve what's coming to you." The twentieth century put a best efforts clause into "Jews, Moral Treatment of." We all saw the clause in action in Nazi Europe. The clause came out of the contract in 1948, with the formation of the Jewish state. And still American Jews, liberals all, vote for the mob rule called social justice and for candidates who'll expunge the American embassy from Israel's capital and continue to fund Hamas as it bombs our relatives.

Rabbi Adin Steinsaltz said that the root cause of anti-Semitism was Christian anger at the realization that the Jews were *not* in charge of the world.

Assimilated Jews once put our chips on the notion that liberals *should* be in charge of the world. The liberalism we embraced was and is essentially atheism with the hope of salvation. But that liberalism has matured into spooning with anarchy.

The abandonment of the Minneapolis police station marked the beginning of the mature phase of an insurrection. As the anarchists solidify their power, it will be remembered as the Fort Sumter of the Revolution.

The liberals who bowed them into power will then, sooner or later, be put against the wall. History records nothing to the contrary.

Our universities have long ceased teaching history, but the anarchists have read it to their profit. These most practical semanticists know that one can influence behavior by influencing speech and, thus, thought. Easy as pie.

From *Terrorism and Communism* by Leon Trotsky, "All who expressed pity for the national banner were forced to be silent. But soon this became insufficient; as in all revolutions, the indifferent were forced to express their loyalty to the new order of things. Those who did not agree with this were given up as a sacrifice to the hatred and violence of the mass of the people."

The Left insists on speech codes, the magical and taboo nature of certain words, and the relabeling of all things God given (sex) and man made (government), according to an ever-evolving newspeak. This, as Orwell taught and we now see, is the calling card of anarchy. We are by turns confused, infuriated, terrified, arrogant, or saddened, but none is immune.

Our schizophrenic meditations are, essentially, the interchange of the two Schpershevski brothers, and the question on the table, "What was it before you changed it?"

CHELM; OR, NO
ARREST FOR THE WICKED

———— ⚜ ⚜ ————

All cultures have beloved fables of the wise (ourselves) versus the stupid (others). Some cast the divide between various animals; see Aesop's fables or the animal myths of Native Americans. (Note: I suggest *Indian Tales* by Jaime de Angulo. He collected them in his years among the coastal Indians of California, at the beginning of the twentieth century. And see Howard Norman's beautiful translations of northern folktales from the Inuit and Cree: *The Wishing Bone Cycle*, *The Girl Who Dreamed Only Geese*, and Eileen Delehanty Pearkes' *The Geography of Memory*.)

Children's books and fairy tales ascribe human attributes to animals. Some literature and much folk wisdom locates excellence and deficiency in our fellow human beings. See *The Ways of White Folks*, by Langston Hughes.

Much of the Jewish humor of my youth was a baffled, and not unaffectionate, attempt to understand the goyim (non-Jews) or our reactions to them. One of my favorites: Two Jews plot to assassinate Hitler. They know he comes around a corner in Berlin every morning at nine thirty. They are in place by eight. They wait with their bombs. Nine comes, nine

thirty, nine forty-five. At ten, one turns to the other and says, "Gosh, I hope he's okay."

My grandmother Clara was born in Hrusbieszów, in what was then Russia. Hrusbieszów, now, for the nonce, in Poland, is on the Bug River, 185 miles southeast of Warsaw. Thirty-three miles to its west is the city of Chelm.

I was surprised when I learned that Chelm was an actual place; for, to me, growing up with my grandmother's Jewish folktales, it was the putative home of the world's dumbest Jews.

An entry-level example: The elders of Chelm decide to submit a petition to the sun. "Why do you shine during the day?" it runs. "Why don't you shine at night, when you're needed?"

In the run-up to 2020, the opening attacks on free speech (that is, the exchange of ideas between human beings) were the cleansing of humor. Gone from the airwaves, and then from the workplace, and then from the home was any stereotyping of race, sex, or national origin (with the exception of indictment of the State of Israel, and its citizens, and of conservatives). In its place we have humorless indictments of political views.

Saturday Night Live featured a Black comedian, Jay Pharoah, doing a vicious impersonation of Dr. Ben Carson. This turn was known to those of my generation as "Rastus, the Stupid Negro." His loathsome attempt at humor differed from the vaudeville turns of Stepin Fetchit and Willie Best not at all. He mocked Dr. Carson, one of the most accomplished surgeons in history, for his deliberate speech. There was nothing funny about the turn; it was appalling and shameful. But it filled five minutes of a comedy show whose sole remaining attachment to comedy was indictment of the Other.

Conservatives shake their heads in sad wonder at the idiocies of liberals.

But we do not wish them dead, shamed into poverty, or jailed; we simply find them stupid. We understand that their passivity in the face of insurrection is culpable but fantasize our revenge not as their torture

on the rack but only as our sad remark when we all share the rubble of Marxism, rationing, and riots: "*Now* do you see . . . ?"

The Chelm jokes were my first exposure to Jewish humor and its basis in our love of ambiguity.

A Jew is sitting in a restaurant, staring at the menu. The waitress says, "Don't you have an opinion?" The Jew says, "Yes, but I'm not sure I agree with it."

I wrote a joke for my best friend, Jonathan Katz, decades ago, an homage to Chelm's petition to the sun: a town wants to save money on its police force, so they pass an ordinance outlawing crime.

That's right, look around.

The fevered Left has been not only emboldened but *invited* by their liberal dupes to destroy the culture, the avowed aim of Marxism. Political opinion has been criminalized; what was the Russian collusion charade but an attempt to convict a citizen of defending his political position?

Having abolished religion, and so sin, it was a short hop to abolish crime. This was foreseen by Samuel Butler in his *Erewhon* (1872). In this utopia illness is criminal, but criminals are treated as invalids.

Now we are emptying the prisons, opening the borders to illegal immigrants, hamstringing whatever police remain after budget cuts, and striking off the books one law after another.

But if those once understood as thugs and vandals are no longer taxed with the penalties for their quondam crimes, what will those acts be called?

They will be called social justice.

SOME LINGUISTIC CURIOSITIES

W e have come to accept the existence of the Department of Home-
land Security, but to one with overrefined sensibilities it is an af-
front. It is not its operations (for which much thanks) but its name that
troubles me. For there is an oxymoron in the department's patriotic de-
fense of our Country and the un-American enormity of its title.

Prior to its confection in 2002 (an amalgamation of twenty-two gov-
ernment agencies) no one, in print, on the street, or in the most pro-
tected recesses of his heart, ever referred to our bright and pleasant
country as the homeland.

The word reeks, of course, of the Teutonic *das Heimat* and so cannot
have been bureaucratized into our speech by anyone either sensitive to
that late unpleasantness or acquainted with everyday American speech.
The phrase is loathsome, clunky, and offensive. It has become less jarring
through use, and so we must let it pass. It obscures no nefarious purpose;
it is merely a fatuity.

The balance is drawn down on the scales' other side by "politically in-
correct." The creation of the Department of Homeland Security merely
required new stationery and embroidered patches, but the harm done

by acceptance of its bureaucratically engineered title has, unremarked, infected our speech, and so our thought. Mouth an enormity long and often enough, and the mind *must* cease its consideration, which is equivalent to accepting it as true—the aperçu not only of Joseph Goebbels but of CNN.

It is not merely the declaration that one and only one mode of political action and thought is correct. Anyone of voting age has always known that the citizens of the other party were depraved fools; this is merely the husk of the poison fruit. At its destructive core, the phrase is an outright threat.

"Politically incorrect" is not an indictment of a rival party but a warning that to embrace (indeed to contemplate) an opposing view would prove inconvenient to the individual.

Observe that every conservative who employs the preface "This may not be politically correct but" is not only acknowledging but aiding the forces of thought control. These forces do not need to be acknowledged, and whether or not they are opposed, they must not be strengthened.

Napoleon said that if we want to know our opponent's fears, we need merely observe that with which he seeks to terrify us. Leftists are terrified of exclusion from the mob and see, everywhere, the exclusion's cost. Imprisonment, vituperation, bankruptcy of conservative opponents, the severity of their punishments fit *not* to the degree of their deviation (to the Left there are no degrees) but to their persistence, having been threatened and warned, in *any* deviation.*

* Here is a parallel to the Left's anti-Trump psychosis: In the 1930s, Churchill was out of power, out of office, demeaned as a warmonger, a fool, an unstable has-been, a lunatic, and so on. The interwar British press and the oligarchy were largely in favor of appeasement, and their influence spread to a populace legitimately unwilling to engage in another war. The British air force was flying World War I planes, the army was minuscule, and many members of the nobility (and monarchy) were actively pro-Fascist. *(continued on next page)*

• • •

We Americans have contempt for informers. Various of our fellows have been, time to time, subjected to various degrees of oppression. I will name African Americans, Jews, gays, Asians, Irish, but we will note that the members of these groups were, in the main, easily identifiable to the oppressors; it required no snitch to inform that such and so was a woman, a Black, a Jew, and so on. And so, we have no tradition of accommodation through delation (a wonderful, archaic Scottish word: it means "denunciation"), which together with ratting out, squealing, snitching, and so on are all, to our ears, loathsome activities beyond the aid of euphemism.

Nancy Pelosi et al. dreamed up some imaginary "whistleblower," a snitch whose unsupported word would bring down a president and undo Americans' right to vote.

That this star-chamber introduction of masked anonymous witnesses is contrary to all American culture can be confirmed by the heavy frosting of the word. (See also Ralph Northam, governor of Virginia, who, in a 2019 interview, seemed to endorse the mother's right to terminate the life of a fetus not only at any time before birth but, in rare cases, after birth, such termination, which some call postbirth abortions, being known, previously, as "murder.")

The House Un-American Activities Committee, of course, is a philosophical grandfather of political correctness.* Here, brave congressmen

(continued from previous page) Hitler saw that Churchill was unafraid, and it was he to whom the Brits in extremity would have to appeal. And Hitler was afraid of Churchill, because Churchill was unfazed by rhetoric, or chicanery, or threats. We cannot hate something unless we fear it. The Left's loathing of President Trump was, finally, terror of one who was not afraid of them.

* Predecessors include the Alien and Sedition Acts of 1798 and Wilson's Alien Enemy Proclamations of World War I, the public support of the latter demonstrated not only through applauding the deportation of German American citizens but through the shooting of dachshunds.

came out to Hollywood to root out Communist influence in the motion picture industry.

As a lifelong member of that cabal, I can testify that our interests have always been limited to sex, alcohol, drugs, status, and envy. Perhaps it is the same in your racket?

In the 1930s and 1940s, Limousine Communism replaced mahjong as the activity adding some zest to life among the sheltering palms. Motion picture actors spend their lives either working or terrified that they will never work again. "Working," for a movie star, means sitting in a trailer fourteen hours a day and being called before the camera once every few hours for ten minutes to play part of a scene.

This is not to demean actors, nor to disparage that brilliance which we find, and adore, occasionally, in a real star. But they not only spend much of their time waiting, and bored, but, when called to the set, spend the remainder, quite literally, in fantasy.

For indulgence in which they are rewarded.

This is a group ripe for rather immediate conversion to *anything*. (Joseph Goebbels reportedly said, give me a fully committed Communist, and I'll make him a Nazi inside a month.)

The inquisitive, the credulous, the bored, and the sociable all were exposed to (and the great majority participated in) discussion groups, study groups, and so on allied to the Communist Party and to Bolshevist aims. Many were as taken in by the fantasies of Russian prosperity and equality as their grandchildren are, today, duped by the ceaseless woke propaganda of state news (many of the sources the same, for example, *The New York Times*), such as reports from Walter Duranty's time in Russia from 1921 to 1934, where he was shown Potemkin villages in the midst of a famine that killed eight million and wrote, "Russians hungry, but not starving" (*New York Times*, March 31, 1933). For which he won the Pulitzer Prize.

Some wag, and it might have been Oscar Levant, said, "Breathes there a man with soul so dead, who was not in the Thirties Red." Communist sympathy was to *mes semblables* in Hollywood not treason but that

self-awarded mantle of superiority found today in the championship of whales, the snail darter, the homeless illegal immigrants, and other creatures great and small, their charm in direct proportion to their remove.

In sum, human beings are deluded fools, and we in show business are paid *to act out* human delusion. Consider it: we are lauded for the parts we play or create, but we are no more capable of actually sussing out the engines of human behavior than is the magician of actually sawing a woman in half.

And so Hollywood came home from the war. The Cold War had the bomb, and Congress, that menagerie, thought it good to overlook the Communists in the State Department* and put a bunch of actors and directors to the question.

Citizens, ideologues, dreamers, and fools even as you and I, who had merely exercised their First Amendment rights to read, to say this or that, or to assemble to discuss it, were hauled in front of a bunch of mitered thugs and given the choice of declining to compound the farce (in which case they were blacklisted and free to starve or commit suicide) or of cooperating.

To cooperate meant to denounce; for how could the tribunal and its cupbearers be more certain of their own power than by causing the accused to commit an irredeemably evil act: betray their friends? Which many did. And, to this day, and forever, "cooperative witnesses" will have, in their biographies in addition to a list of films and awards won, the notation of their perfidy.

We do not like informers here.

And so, in Hollywood, we see our (no doubt free-range) chickens, once again, come home, at the lectern of Eric Garcetti, mayor of Los Angeles. In his speech of March 31, 2020, he urged Angelenos not only to wear masks, and keep social distances, but to *inform* on any businesses

* See *Witness* by Whittaker Chambers—one of the great books of the twentieth century.

not observing the lockdown. And then, like most who go too far, he of course went further.

"You know the old expression about snitches. Well, in this case snitches get rewards."

We all know what snitches get (ancient ghetto saying "snitches get stitches"), but Garcetti says, "Snitches get rewards."

From whom?

From the government. What would such rewards be, and what wretch would violate the ancient strictures against delation—not because of appeal to the good of communal health, but in hope of receiving a government reward?

Anyone *you* know? Would you continue to know them after they had done so? Allen Ginsberg wrote, "I still haven't told you what you did to Uncle Max after he came over from Russia" ("America," 1956).* This is what they did to him: Eric Garcetti and the prodrome of the emergence of the *nomenklatura*.

Yes, language was invented to mask feelings, but the observant may listen and learn not only from bold or suave attempts at obfuscation but from unconscious alteration and neologism.

Politicians long reminded us that we were shareholders in the American experience. This was fulsome drivel akin to reminding one's spouse that "she's like family." But, though political impertinence, it had the merit of being (at least theoretically) true. Each citizen, through his vote, "owned" one share of the country.

Over the last decade "shareholder" has been replaced by "stakeholder." I will remind my readers that a stakeholder is an onlooker to a gambling event.

* Ginsberg continues: "I'm addressing you. / Are you going to let your emotional life be run by *Time* magazine?"

The contenders in the wager trust the stakeholder to hold their respective bets (the stakes) and at the contest's conclusion to award them to the winner.

The stakeholder is one who, *by definition*, can have neither interest nor profit in the outcome.

I believe no further comment is required.

THE NAZIS GOT YOUR MOM

❧ ❧

In the good old days, South Shore, Chicago, 1950s, we played softball in the street. We were a tiny Jewish enclave, between Jackson Park to the north, the Irish south of Seventy-First Street, the African Americans west of Stony Island, and the lake to the east.

The lakefront directly east of our house was held down by the South Shore Country Club. It was restricted, which meant no Jews allowed. But our little neighborhood was Jewish. All of the grandparents and many of the parents spoke poor English with an Ashkenazi accent. All of our fathers had served in the war, and many of them, we saw at the beach, carried the star-shaped scars of bullet wounds.

None of our parents ever spoke about the war, but most houses had a shoebox somewhere holding mementos; I recall Hitler Youth daggers, ribbon bars, discharge papers, various pistols, dog tags. Part of the information on the dog tags was the serviceman's religion. Our fathers' and our uncles' dog tags were stamped *H* for Hebrew. For the Jewish soldiers who fought in Europe, surrender to the Nazis meant death by the roadside or in the camps.

We played softball in the street. One would be up to bat, and in a

tight spot one's teammates would exhort one to a supreme effort by saying, "The Nazis got your mom."

I had two errands to do this morning. One was to get my wife's belt stitched, and the other was to buy a book.

In the lockdown, and the riots, I'd had even more time than usual to read. I had discovered, and I'll share with you, a complementary pair.

Ninety Times Guilty (1939) and *A House Is Not a Home* (1953). The first is by Hickman Powell, a reporter. It is the story of the pursuit and prosecution of Lucky Luciano, by Thomas Dewey. Luciano made his fortune in the 1920s and 1930s by shaking down the prostitutes and madams of Manhattan. Dewey nailed him on conspiracy charges, and he went to prison.

One of the madams Luciano shook down was Polly Adler. *A House Is Not a Home* is her autobiography. Polly ran the most famous whorehouse in New York. The two books will delight both individually and especially if read in tandem.

Hickman Powell was a hell of a writer. See also his *Last Paradise* (1930), about the year he spent in Bali. My wife pointed out that not only did Powell comment, multiple times, on the beauty of the near-naked Balinese girls, but he *always* added that their naked nubility left him, curiously, sexually unmoved.

Now, as to the Polly Adler book. It is a droll and rip-snorting tale. As it should be, for it was ghostwritten by one of the greats. Her name is Virginia Faulkner, and no one has heard of her for quite some time. She wrote three novels (*Friends and Romans*, *The Barbarians*, *My Hey-Day*), and they will have you screaming with laughter. For example, from *My Hey-Day* (1940), "My Soviet Adventure":

> I made the journey in a sealed freight car wedged in between a tractor and a youth-movement, and, naturally, as soon as possible after arriving, went to a beauty parlor to pull myself together and

learn what I could of conditions. And I want to go on record as saying that no matter *what* you hear about Russia their beauty parlors are most economical. You can get a shampoo, wave, massage, facial, manicure, and abortion all for about seven rubles ha'penny.

The first person I tried to look up was my dear friend, Grand Duke Slavko, one-time head of the Imperial Police and author of So You're Going to Siberia!

Faulkner was more droll than Dorothy Parker.

Also, during the unpleasantness, I took down from the shelf three memoirs by Russian aristocracy, written after the revolution: *Half a Life* by Count Benckendorff; *Upheaval* by Olga Woronoff; and *Once a Grand Duke* by Alexander.

Alexander was first cousin to Nicholas II. He fought in the Russian navy in the Russo-Japanese War and founded the Russian air force. In England, in 1930, he wrote of his attempts to get Nicholas to show a little backbone in the war and in the revolution. He writes that World War I could have been averted by the exchange of two telegrams between the tsar and the kaiser (first cousins) and the Russian Revolution stopped by one company of Hussars in the suburbs of Moscow in 1917.

If this last seems familiar to the reader, it should, for we saw it in Minneapolis. But perhaps the greatest lesson of history is that we never learn from history. And that no great crime was ever committed save in the name of progress, or its stablemates historical necessity and redress of past wrongs.

Now my library was exhausted. So I went online and inquired of our local and superb BookMonster. Yes, I found, it was open, but "for curbside service only." Well, what's the good of *that*? The whole point of a bookstore is browsing, or, if you will, "speed-dating" literature.

No, no, no. If I knew what I wanted to read, I'd order it online. Which is the best (to me, perhaps the only) upside of the internet.

I tried again, the website of my neighborhood "airport books" emporium. They are jam-packed with volumes denouncing Trump, but they

(and I must use that saddest of words "still") have the carousel of Penguin Classics, and one never knows. (I found Nella Larsen's *Passing* there last year.)

Well, their web page reported, to my joy, that they had opened. It also says that they offer their support to the community in the midst of this pandemic, which, they go on to say, is of course the centuries-old plague of systemic racism.

Now, I don't know what systemic racism is, but neither does anyone else. Like social justice, any communicable meaning is destroyed by the adjective. Both terms are indictments of human evil; its perpetrators are easily identifiable: they are those who request a definition.

So much for *that* bookstore.

My second errand was to the shoe shop, also right around the corner from my house.

Here's a joke. A bank robber was arrested in Chicago last week for refusing to wear a mask. I put up my bandanna as I entered the shoe store. I'm saddened to have to go along with the farce, but I have heard, and intermittently practiced, "Don't go looking for trouble, until trouble comes looking for you."

I completed my errand at the cobbler's, came to my office, and took up a book on aviation in Los Angeles. This is where American commercial aviation began, where they built the *Spirit of St. Louis* (yes, down the coast a bit), where Amelia learned to fly, and where the first round-the-world flight originated: the Douglas World Cruisers, 1924, built right here in Santa Monica.

Douglas later moved to Clover Field, now Santa Monica Airport, where it made many of the warplanes and the transports of World War II. But the World Cruisers, I found, were built in a shed on Wilshire Boulevard, on the block that today holds the cobbler's shop.

America was attacked in 1941 and defeated Japanese militarism and European Fascism in three and a half years from a standing start. We in the twentieth century, or its first half, didn't go looking for trouble until trouble came looking for us. And then we ended it.

When we forgot the maxim, we came home by Weeping Cross.

At which crossroads we now find ourselves. For, as free speech becomes, increasingly, a black-market commodity, the Nazis got our mom.

Trouble has sought us out.

From Rudyard Kipling's "Epitaphs of the War":

BOMBED IN LONDON

On land and sea I strove with anxious care
To escape conscription. It was in the air!

DEMOTIC, A CONFESSION

American screenwriters and dramatists of the 1920s and 1930s grew up under the influence of Gorky, Chekhov, and the Bolshevist films and novels of the workers. They created, from that influence, a new form, less tendentious, more American, and more exciting: the "gang drama."

Here the hero was not "An Oppressed Everyman Worker" but a *group* of human beings, tied together by their devotion to and difficulties with their job.

This is a pretty good example of the perennial rediscovery of the vexed dramatist: "If I can just keep 'em together long enough, they'll have to work something out. How about a snowstorm?"

The first and greatest American gang drama is *The Front Page*, about a newspaper city room. See also Sidney Kingsley's *Men in White* and *Detective Story*; Odets's *Waiting for Lefty*, about taxi drivers; and the explosion of gangster films, the first and best written by Ben Hecht (who gave us *The Front Page* and *Scarface*).

These took us into a fictionalized, hermetic world and put us around the watercooler or the pool table, listening in.

My earliest plays were of this genre: *Lakeboat*, about the merchant marine; *American Buffalo*, a crime tragedy set in a thieves' den; and *Glengarry Glen Ross*, a drama about life among real estate hustlers.

The Front Page, and my early work, were notable for their (at the time) shocking use of demotic (that is, profane) speech.

The Front Page brought the house down, and the box office up in 1928, with "The son of a bitch stole my watch!"—the best curtain line of all time.

My early dese-dem-dose excursions into free verse were, at first, condemned for the use of obscenity, much of the criticism implying that anyone who chose to descend to that cheap trick could do as well as I, and had I no shame?

Novelty in art can be dismissed by critics at no risk, and has most usually been so treated. The gracious artist might translate the critical objections as "I don't understand" and temper his fury with some pity for a fatuity that dismisses anything that does not stink of the pan.

Exuberance may frighten and so anger many who prefer anger to confusion, but there is this in the critical affront: the violation of norms *will*, *eventually*, lead to chaos. As will every other operation of life, as Newton taught us. The question is only the direction and length of that path.

Mark Rothko's masterpieces inspired museum curators, but a few years down the pike, to mount exhibitions of monochrome canvases and then of frames holding no canvas at all. Walt Whitman's heartfelt drivel has bequeathed us the poetic trash of today lacking even the defense of a full heart. The exuberant whimsy of the Dadaists becomes *Piss Christ* and Christo's wrapping of the Central Park trees in saffron plastic. Isadora's "nightgown dancing" and Loie Fuller's butterfly impressions devolve into Marina Abramović sitting in a chair beyond "the naked living door" at the Metropolitan Museum while folks line up to have ten seconds staring into her eyes and weeping. (This, by the way, is a praiseworthy rediscovery of the psychological engine of Disneyland. There, one spends, by my watch, fifty-five minutes standing in line for a two-minute ride.

Either the experience then was, as advertised, transformative, or one has been had.)

The beautiful nudity of Hedy Lamarr in the 1933 *Ecstasy*, of Jane Wyatt in 1937's *Lost Horizon*, or of Maureen O'Sullivan, as Jane, in 1932's *Tarzan the Ape Man* has led, of course, to the hard-core pornography that punctuates most of contemporary television; and the ubiquity onstage and in film of what was once called "street language" is due, to a certain extent, to the success of my early works.

"Why, hell, *I* could do that" is, any artist knows, both an enormity and a compliment, and the successful artist knows that the same dyspeptic souls who ridiculed his early work will, should he continue in success, curse him for not continually creating the same things for which they had originally abused him.

Most writers stay at the fair too long, and I am not in a position to proclaim myself an exception. (An interviewer, some twenty years ago, took umbrage at my output. "Why do you keep writing," he said, "don't you have *enough* money?")

One may, of course, achieve immortality, but to do so, one would have to live forever. Some may extend their place in the public eye if they possess sufficient (good or bad) luck, stay in the middle of the road, stick to the old stand, and don't let their private affairs get known. (Harvey Weinstein, we will remember, had a good long run and enjoyed the respect of all who did not know him.)

But in the empty watches of the night, and in this sobering time, many may do an inventory, calling it an examination of conscience, or a meditation, or a review, and ask, how did I (we) get here; why was I punished/spared, what the hell is going on, and what can it all mean?

My family was friendly with Syd Simons, the makeup artist, who primped Kennedy and Nixon in 1960 for the first televised presidential debate. He boasted that he is the man who got Kennedy elected.

I do not mean to slight the memory of either Sam Giancana or Jimmy

Hoffa, but perhaps Simons was right. In any case, he probably contributed, as do you and I, to that which the religious understand as a mystery, and the Left "a series of loathsome mistakes": life.

In *Anna Karenina*, Tolstoy writes of Prince Vronsky, sitting down, once a month, at his desk, to "do the laundry." My particular discovery, in "taking stock," was prompted by musing about Bernie Sanders.

Now, we are all suckers for a pretty face. One, with the best of will, cannot say he has one. Nor does he have a pleasant or indeed a bearable manner, but some, in this great land, found his crouched, finger-pointing yentism merely the performance of a deeper truth and moral imperative, reducible to "stop working, tax the productive until *they* stop working, and let the country go to hell."

His party turn called to my mind one of my favorite statements by Mr. Twain. Asked to come to some gathering to meet unusual and interesting folks, he said he'd already met them before: he met 'em on the river. And I met Bernie Sanders and his like in Vermont in the 1960s and 1970s.

For I was one of them; my group were expat and, by mutual courtesy, intellectual Jews, refugees primarily from New York (myself from Chicago), who washed up in central Vermont in the late 1950s and early 1960s and found it good.

Why did we come? It was, and is, the most beautiful spot on earth, it is close to cities (Cabot, where I lived, is 25 miles from Montpelier, the state capital, and 175 miles from Boston), and the living was cheap.

My friend Andy bought his hundred acres and an 1800 post-and-beam farmhouse for ten grand in 1960; I bought a similar spread for fifty grand in 1978.

We expats lived much as did the Lost Generation in the 1920s in Paris. We were essentially remittance men. What money we had was made (by ourselves or our forebears) in wealthier economies and went a very long way in the end-of-the-farm-life villages of central Vermont.

Some canny souls started a hippie school, Goddard College, in Plainfield. I graduated from the school in 1969 and returned to teach acting there from 1971 to 1973.

We "year-round-summer-people" were all artists or artisans of some stripe or profession. Howard Norman and myself and Andy Potok were the writers, Charlotte, Andy's wife, was a world-famous potter, Jules and Helen Rabin baked the world's best bread, Steve Bronstein was a blacksmith, Gary Katz ran a nursery, and Ben Koenig ran the country bookshop. Our crockery, furniture, fabrics, and so on were largely locally made, and the stuff in our homes was pieced out through the auctions and barn sales held through the warmer months.

Our expat group was involved, as it were, in "passing," in a community where no one would call us out as fallen-away Jews. The locals treated us, our self-possession, arrogance, and folly with Scottish reserve and generosity that, I believe, none of us appreciated and that we all certainly took for granted.

Most of us freelanced, in some capacity, at Goddard College, our milch cow. The school, which offered no classes, had additionally confected a scam called the "work-term," two months off in the middle of the school year, during which students were charged to "be somewhere else"; and, enlarging on a good thing, the Adult Degree Program, which sold BAs to folks who had the tuition and the price of the stamps with which they mailed in their assignments, "keeping journals."

They also paid for, and received, the right to show up on campus several weeks a year, "play student," and exchange tips on how, on their return to the world, to explain their venereal diseases to their spouse.

A merry time was had by all. The men (myself included) were hiding out from the Vietnam War, and we (myself included) excused our cowardice (in sitting it out or not going to jail) by busing to Washington once or twice and standing in a group.

I saw the first flowerings of Black Power there in 1971, when an African American woman on receiving her degree commandeered the graduation ceremonies to lecture us at glacial length on our loathsome genetics; and my first glimpse of feminism, rampant that same year, when the fellow who was playing the lead in my production of *Anna*

Christie quit, the afternoon of the opening, because his girlfriend had explained to him that the play exploited women.

But there was an even darker undercurrent to this jollity.

Plainfield, Vermont, home of the college, is sixty-five miles south of the Canadian border. In the 1960s, the school was a hub of draft resisting and draft dodging and a nexus of the counterculture. I saw Stokely Carmichael lecture there and Anaïs Nin (truly), and someone recruited for the Weather Underground.

Two of my friends, unknown to me, were Weathermen and involved in the Eleventh Street bombings in New York City in 1970 and went underground for thirty years, and the school and the Plainfield community were the Walmart of the Northeast's 1960s drug trade.

We students took not only to the more muscular activities of revolution but to the gamelan (a Balinese orchestra that, like the great, cheap table wines we drank in France, "does not quite travel"); there was a huge interest in the study of mime (pretending to pick a flower) and in working in the Clock House, the college's nursery school for the instructors' kids, where we student-teachers were taxed with the rote memorization of the phrase "learning through doing."

Academic credit was given not only for "life experience"—that is to say, for cash—but indeed for actual crime. A classmate burned down the school's guardhouse, and wrote a thesis explaining it as an expression of his understanding of Heidegger, and received his degree.

And we held "encounter groups," weekend-long gab sessions of no sleep, much drink, dope, mutual confession, and weeping. It was, in short, that freak show which might be seen today in some areas of our great cities and in all of Northern California.

Paul Krassner was the publisher and editor of the counterculture rag *The Realist*; he came to speak in 1969. He, it may be remembered, printed this foldout bumper sticker in the mag in 1963: "Fuck Communism! Additional copies available from the Mothers of the American Revolu-

tion." In this we might see an early iteration of that bold iconoclasm not only of Bob De Niro's impassioned soliloquies but of Nancy Pelosi's attempts at origami. To which trend I have contributed. My part of the program was called free speech: "Now we are engaged in a great civil war, testing whether that nation, or any nation so conceived and so dedicated can long endure."

Tolstoy at the end renounced his works, his wealth, and all precepts save an irreducible, pre-Paulist Christianity. He ran barefoot through the snow and had to be dragged back home, bundled up, and given a hot toddy. I find myself today in a beach chair with a Negroni, my reminiscences leading me to similarly wonder, "What have I done?"

I have done my three score and ten and may soon be released into that more general organism: "To be yourself in a universe which is constantly conspiring to make you something else is the greatest accomplishment," Emerson. And note the derivative: "Silence tells me secretly, Everything, Everything" (Ragni and Rado, *Hair*, 1967).

To both of these aperçus one must respond, "*What . . . ?*" the truest answer to which is, "Who knows the time in which he lives?"

GRIEF AND WISDOM

For in much wisdom is much grief and he that increases
knowledge increases sorrow.

—Proverbs

It seems Marx was correct, that capitalism inevitably matures into
Communism. But his wisdom stopped there, as for him, it must have,
for he postulated Communism as the end of history.

History, however, has continued despite his pronouncement, and
Communism wherever it was instituted matured into savagery, human
social interaction mimicking the physical, where all expense of energy
(life, heat, and motion) results in entropy.

It is attractive to consider this eventual entropy "the mind of God."
I don't know how it can be imagined differently. But this is, at once, a
tautology, for "the mind of the divine" is simply a religious version of
"the unknowable." Is this eschatology? How otherwise would an old man
occupy himself? It comforts the senescent to believe that something will
come after him. And something will come after *me*, as Ira Gershwin
taught, " but not for me."

Is it a sadder reflection that the civilization and its works will not
continue than that of course they will but I shall not? Of course. But I
imagine my forebears butchered in Europe in the years just before my
birth. Some went to their deaths chanting psalms, some screaming in

terror, the majority too demoralized even to consider taking one of the murderers with them.

Leftist America is following Russia, China, North Korea, Venezuela, and Cuba into slavery. That we lack a dictator for the moment restates Tolstoy's question. He asked why five million Frenchmen would march to their deaths in Russia. How, he wondered, could one man, Napoleon, exercise sufficient power? He concludes one man could not, which leads him to ask, "Then what *is* power?" And he responds that we do not know.

Is it God's plan that mankind must revert (individually or in groups) to savagery? This leads to a Zoroastrian view of the universe: either God wills it, or there are two gods, one of evil, one of good. Judaism rejects the notion, as does Christianity, but how to account for evil? In the individual it can be explained by ignorance of God's Laws, but how then to account for it in the mass? For the descent into statist savagery, though it is self-described as a holy idolatry (worship of race, of sexual preference, of disability), transcends idolatry, because it transcends the individual will. Naming it idolatry—which it is—merely removes the question; we know idolatry is evil, but, again, what is *evil*?

The terrified populace of the West covers their mouths to restrict speech, shies away from each other, and shouts down any who are pointed out as not of the herd. Unelected bureaucrats issue ordinances strangling the economy; vandals promise riots should a dissentient voice be heard; and a supposedly sensible electorate complies. They understand their complicity as social responsibility, but it is fear. But fear of *what*? Of self-direction.

I was flying low, just off the beach near Malibu. There was a pod of dolphins milling. They heard the plane and began to disperse. Several hundred of them swam off, evenly spaced, in a water ballet of a perfect circle.

I must say that God made the dolphin capable of acting thus, with a communal intelligence. God has made us similarly. But, as the dolphin is incapable of evil, I must wonder if we, as a species, are capable of good.

The Declaration of Independence stands in the same relation to the Constitution as does the Torah to the Talmud. The Constitution is the

working out of laws and procedures to *implement* the underlying state-
ment of purpose and resolve that is the declaration.

The declaration, to extend the conceit, bears a direct relationship to
the Torah. Not only is it a profession of God's will that humans be free;
it is a contemporary rendition of the story of the ten plagues.

We are told God afflicted the Egyptians to inspire them to let the
Jewish slaves go free.

But they can also be understood (in contravention of the biblical text,
but in a, I believe, permissible dramatic or analytical understanding of its
meaning) to've been visited on the slaves. To wit: *Now* will you leave? /
Now will you leave?

The plagues escalated in severity until the last, death of the firstborn,
was coupled with God's injunction to the Jews to smear blood upon the
doorposts of their homes—that is, to announce themselves to the Egyp-
tians as the proximate cause of the slaughter.

The signers and framers read the Old Testament as regularly as our
contemporaries watch the news; the plagues are recapitulated in the
abuses of the Declaration.

Of King George:

He has refused to assent to laws the most wholesome and neces-
sary to the Public Good.

He has forbidden governors to pass Laws of immediate and
pressing importance unless suspended in their operation till his
assent should be obtained, and, when so suspended, he has utterly
neglected to attend to them.

He has refused to pass other laws for the accommodation of
large districts of People unless those people would relinquish the
rights of Representation in the Legislature.

We may stop right there, and reflect that the corona shutdown, a
perhaps legitimate (if erroneous) response to a virus, has been employed
as a political lockout by the Left.

Folks old enough to have been around the block and thus, perhaps, progressed in the most possible human approach to wisdom—sadness— saw in the run-up to the 2020 election the two serpents of insurrection displayed in the marketplace, and the populace invited to choose: If the Democrats won, the economy would be opened, restrictions would be lifted, and a vaccine or other fig leaf would be produced to explain that the lockdown had triumphed due to the appointment of the new king. If Trump were to win, all knew the rioting and looting would recommence and that his years of office would, again, be occupied in crime and revolt called protest.

This was the choice the media and their employers in the Democratic Party presented to the country: peace in slavery, or the certainty of armed rebellion.

From the "abuses":

He has erected a multitude of new offices, and sent hither swarms of officers to harass our people and eat out their substance . . .

He has combined with others to subject us to a Jurisdiction foreign to our Constitution, and acknowledged by our laws; giving his assent to acts of Pretended Legislation.

The abuses continue: he is indicted "for taking away our charters, abolishing our most valuable laws and altering fundamentally the forms of our Government. He has incited Domestic Insurrections among us."

And there may we read all about it.

There *is* no "new Man or Woman," and there are no new modes of sin and collaboration for the purposes of sin. They may all be found listed in the Bible, and an interested student can easily puzzle out their current aliases.

The lockdown was the manipulation by those in power of the response to a natural phenomenon. In this it resembles the Left's insistence on global warming: fear gives power to the governments, who are, as always, the tools of the plutocrats. Why would the plutocrats, the

trillionaires, the controllers of our communications, want the economy shut down?

So it could be repurchased cheaply.

The robber barons of the nineteenth century went by the names of King of Steel (Carnegie), of Oil (Rockefeller), of Railroads (Drew, Fisk, Harriman), and so on. They were, primarily and always, stock manipulators. They amassed the greatest wealth the world had ever seen through stockjobbing, destruction of small industry, and its bargain-basement purchase. They would then amalgamate the repurchased individual mills, refineries, roads, pipelines, issuing stocks, most of which were "water."

Then they would manipulate the price of these essentially worthless stocks: issuing dividends (derived from the sale of stocks) to drive the price up (a Ponzi scheme), while previously having bought futures; then they would drive the properties they controlled to ruin, having first sold short. I recommend Matthew Josephson's *Robber Barons* (1934) as a practical guide to the same depredations today.

Why would the oligarchs of Silicon Valley, the richest individuals ever on the earth, want more power? Why would you? Why would I? Does the possession of money exempt one from human vanity, acquisitiveness, arrogance, and pride?

The career of the robber barons, then and now, is that of Nebuchadnezzar, who continued amassing wealth until he went mad and ate grass.

The news yesterday reported that an Israeli rocket scientist and satellite expert revealed that the world's leaders have long known that alien beings are among us.

My response, perhaps, like yours, likely, "So what?"

Are alien beings going to be more wise? How would they disseminate their wisdom save through the channels that are already committed to spreading fear and ignorance?

Might they have a society superior to ours? How would we so decide? But perhaps they would be sufficiently wise, strong, or adept to spare us the necessity of choice, which they would, in their wisdom, conclude would only be to expose us—their inferiors—to a further burden.

TIME TRAVEL

⟿ ⟾

My daughter Clara, aged four, began a speech, "When I'm a baby again . . ." Equally, I, her father, find myself periodically rehearsing the caveat that should I reappear in 1929, I must sell short before October, and, the more pressing admonition, if on the sinking *Titanic*, there were half-full lifeboats offering safety on the starboard side.

Speaking of which, Walter Lord (1917–2002) was a *Titanic* scholar and a hell of a writer. See his book *A Night to Remember* and the superb film that was made from it. An interviewer asked Lord where, if he could travel back in time, he would like to be on that night at sea. He responded instantly, "On the *California*."

This was the merchant ship, hove to, ten miles off. The sinking *Titanic* sent up distress rockets and constant radio calls, but the *California* did not respond.

If I could travel back in time, I'd go to 1927, to the opening of *Show Boat*. It's reported the audience was so stunned at the play's conclusion they sat immobile for some minutes before they began to shout their applause. The genius Jerome Kern, an American Jew, took "The Song of the Volga Boatmen" and turned it into "Ol' Man River." We can see the

show's concluding reprise of that number in the 1946 film *Till the Clouds Roll By*. The film is pretty good MGM Technicolor moosh, with the fig leaf of a story. But the musical numbers are swell, and the finale is astounding. It is a re-creation of the exact staging and employs many of the same performers who played onstage in *Show Boat*.*

I never entertained fantasies of "going back to fix things," because I grew up in Mayor Daley's Chicago and could translate the phrase correctly as "pay me or I'll make it worse." And what on earth does more damage than a reform administration?

There's vast literature of time travel. In H. G. Wells's *Time Machine* the Edwardian traveler to the future finds a humanity peopled by the gentle fainéant Eloi (liberals) and the vile subhuman workers, the Morlocks (conservatives).

Wells, here, is recasting Swift's vision of Gulliver among the Houyhnhnms. These are sentient horses, incapable of falsehood, greed, lust, and all their companions. They keep, as slaves, the Yahoos, vile, stinking, depraved creatures (humans).

Edward Bellamy had a similar vision of perfection in his *Looking Backward* (1888). Its hero, Julian West, falls asleep and awakens 113 years later, in a perfect world. Here disease, crime, and private ownership are unknown. All share equally, and all is peace.

The book spawned Looking Backward Clubs and was influential in the formation of various schemes of social improvement and the promulgation (though unattributed) of Marxist thought. (With thanks to Wikipedia.)

Bellamy, like Lincoln Steffens writing of Stalin's Terror, "had seen the future, and it works." But like all liberals, he was not around to pick up the check.

In *The Star Rover* (1915), Jack London's hero is the convict Darrell Standing. Tortured in San Quentin State Prison, he learns to leave the

* Stanislavsky said that the most important part of any play is the last ninety seconds, and he had that right: if it's the conclusion of *Boléro*, you can not only pay the rent but destroy your kids through luxury.

body laced into a straitjacket and travel through time. He does not influence events, but merely experiences them, for example, dying at the Mountain Meadows Massacre in 1857. We see the same device in G. F. Borden's magnificent war story *When the Poor Boys Dance* (1995).

Here a young marine recruit is accidentally abandoned on a training mission in the Mojave Desert. As he tries to walk his way out, he is transported to the great marine battles of the past. In each he behaves heroically, and in each he dies while doing his duty.

We have the comic treatment in Twain's *Connecticut Yankee in King Arthur's Court* and myriad science fiction and fantasy books in which the hero sets out to the past to forestall a wrong.

What Jew of my day didn't entertain the fantasy of killing Hitler?

The power to alter the course of events is given to few, those known as heroes, Lincoln, Churchill, Dr. King; and monsters, Stalin, Mao, Pol Pot. But what of a possible third category, preternatural beings both omnipotent and omnibenevolent?

Mired in the present, I could not enjoy surprise at the discovery of *Show Boat*, but the enforced leisure of the current jollity allowed me to read widely and rapaciously, and I discovered William Godwin.

He was an early nineteenth-century novelist, the husband of Mary Wollstonecraft (*A Vindication of the Rights of Woman*, 1792) and the father of Mary Shelley. Many observed that her *Frankenstein* (1818) was inspired by her father's *St. Leon* (1799).

Here Count Reginald de St. Leon romps through various wars of the sixteenth century, pursuing honor and fame. He gains both, returning home from the Spanish wars in high renown. He marries the beautiful Marguerite, who, get this, was taught drawing by Leonardo da Vinci.

All is hunky-dory until he gambles away his fortune and hers. They retreat in near poverty to a cottage in Switzerland, and St. Leon learns to appreciate the beauty of a calm mind and simplicity.

He is despoiled of his meager but sufficient house and land by a bad neighbor. He applies for public relief and is banished from Switzerland for his (a foreigner's) impertinence.

Things are eventually put aright, and Reginald and the flock return to simple Lake Constance and life down on the farm. But then a mysterious stranger arrives. He is ragged and near death. He confesses that the Inquisition is hot on his trail, and Reginald hides him. In return, the stranger reveals to St. Leon his secret: that he can transmute base metals into gold and live forever.

He entrusts St. Leon with the philosopher's stone and the elixir vitae. And then things begin to go *truly* wrong. St. Leon restores his family fortune, but bad neighbors want to know how he came by it. His son asks for an explanation, but St. Leon, sworn to secrecy, cannot supply one. His son then says that honor demands that he, the son, leave his father's presence, change his name, and distance himself from the shame his father (obviously concealing a crime if not a sin) has brought on the family name.

The fat now being in the fire, Reginald travels throughout Europe. His efforts at beneficence (he forestalls a famine in Hungary) awaken suspicion and hatred among the nobles and the horror of the mob, suspecting (correctly) that he is a sorcerer. His wife dies, his daughters marry, and he gets himself imprisoned and then flees, hounded through Europe by everyone and his uncle Max.

It is, of course, the story of Midas and that of the well-known (and perhaps actual) winners of the lottery, who go from rags to riches to rags just that quick. *St. Leon* is a page-turner and, should one desire it, a Cook's tour of politics in sixteenth-century Europe, the punch line of which we find today, in any rational reduction of "our current situation," as have our saddened brothers and sisters since the dawn of time: "I guess I'll just play these." For who is wise enough to understand, let alone to change the time in which he lives?

But what of the wish to travel through time to meet the great? We might want politicians to kiss our babies, but no one who has ever lunched with them desired to repeat the experience.

Those who might like to meet admired authors would do well to recall the wisdom of Hemingway: "Madame, it is always a mistake to know

an author." As it is, for anything of worth we might have had to say we've written, and expecting an author to "be interesting" is like requesting Gutenberg to "say something in movable type."

No, the wish for time travel is fine fantasy, but most fantasies end badly. I will note both Pandora's box and Wilson's Fourteen Points. See even the seemingly harmless wish to "be a fly on the wall." We might wish to be such, for example, during a conversation between Roosevelt and Churchill, but should such a wish be granted, we should find, to our dismay, that we'd forgotten to add that at the conclusion of the conversation we should *cease* being a fly on the wall.

MOBY DICK

—⟨⟩—

A White Whale, beset by what he feels as undeserved perse-
cution, seeks peace and time for reflection in a new portion
of the ocean—only to find there new challenging difficulties;
and, as he comes to realize, new presentations of those he
fled.

—from *The Coverage*

The magician Joseph Dunninger (1892–1975) was a contemporary
and friend of Houdini's. Dunninger began with many of the same
gags but, early on, came to specialize in mentalism. He was one of the
earliest performers on network radio and, later, in television.

Such was his fame that his name became a punch line.

Many early films contained a joke on the order of this:

1. Where did I leave my keys?
2. What am I, *Dunninger*?

Most mind readers before him did a two-person, or "code," act. One,
usually a woman, would go into the audience, take any item given to
her, and ask, "What am I holding?" And the mentalist onstage would re-
spond, for instance, "a handkerchief." The clue, in this example, "hold-
ing" equals "handkerchief." Or, "Now, this is *what*?" "A watch"; "what" equals
"watch."

This is an oversimplification of a most basic code. The great performers were usually man and wife, working up and practicing their code over many years. Dunninger worked alone. Many of his effects have never been duplicated.

Asked how he performed his miracles, he replied, "It's just common sense. And practice. There's nothing I do that a twelve-year-old child couldn't do, with thirty years of practice."

His routines, like those of any magician, were inspired by, and many derived from, those of his predecessors. The illusion of simplicity is the great achievement of the artist. And Dunninger offered a ten-thousand-dollar reward to anyone who could substantiate that he worked with an accomplice. This, to any magician, or their admirers (myself), translates as "he got away with it." And more power to him.

But what of the notion that anyone could perform his effects with "a little practice"?

Yes and no. Dunninger had that inspiration or predisposition without which there can be no art. An essential part of this gift is an *addiction to practice*.

In the actual artist practice may be delight or slavery, but it's compulsory, and this compulsion separates the artist from the amateur, journeyman, or hack. Those who aren't *driven* to practice may as well fess up and go into real estate, write home for money, or teach.

The artist practices in order to *know*.

Now, the search for knowledge, the Bible informs us, will *always* lead to sorrow: the more one knows, the more one becomes aware not only of one's wickedness but, more troubling, of one's inadequacies; simultaneously, the quest reveals the object ever receding.

Or, in English: you have to sit there.

Which, to the artist, is going after the whale.

Hemingway said that writing is easy: all you have to do is sit at the typewriter and bleed.

The Marxists would say that *thought* is not work. But I doubt Marx, a writer, would have said so.

It's the oddest damned job, and one cannot leave one's work at the office.

Snakebit writers are like the cross-country driver. He has spent x days on the road from New Jersey. He arrives in Oakland and gets out to enjoy his triumph. But it is not found in Oakland. So he returns to the vehicle of his triumphant quest. He goes back to sit in the car.

REAL LIVE

———— ❧ ❧ ————

In 1962, Carolyn Leigh and Cy Coleman wrote this lyric: "Pardon me, miss, but I've never done this with a real live girl . . . I'd rather gape at the dear little shape of the stir and the thrill of a real live girl." The song always puzzled me, because I could only interpret it as the testimony of a recovering necrophiliac.

I found another example of calm acceptance of the macabre in Rodgers and Hart's "With a Song in My Heart," where we find, in the break, "When the music swells I'm touching your hand. It tells that you're standing near." Unless the hand had been separated from the body, where else could the addressee be standing? Is this the serenade of an ax murderer, or "just one of those things"? (Cole Porter.)

All the above are from Broadway musicals, that American coagulation of folk opera and treacle. But jeez, they put the tushies in the seats.

Now we are engaged in a great civil war, testing whether this nation or any nation so conceived and so dedicated can long survive. (A. Lincoln.)

But we are not met upon a battlefield of that war. The battlefield for the culture is, of course, New York City and its dominions. Plays can be

streamed to the populace, but this is far from the real thing, as phone sex from physical intimacy.*

There existed, in Manhattan, until January 2020, a live, national theater.

No play could be disseminated to the hinterlands until it had played Broadway and won the approval of *The New York Times* (a former newspaper). Thither we showfolk all therefore went, and equally thither those seeking both entertainment (the boast of treacle) and the adventure of wagering money and time against the possibility of encountering actual talent, insight, or humor, that is, art.

I not only have worked onstage with the greats of my own day but was blessed to've seen those of previous generations. I name Alec Guinness, Peter O'Toole, Ingrid Bergman, Henry Fonda, José Ferrer, Richard Burton, Ethel Waters, James Earl Jones, John Gielgud, Wendy Hiller.

I recall Peter O'Toole in *Man and Superman*. He came on, and for the first thirty seconds I thought him some sort of oddity, and then I was transported, for the oddity *did* exist; it was and is called talent. It flows over the footlights in a blessed immediate communion between the artist and the audience. But it don't flow over no stinking footlights on no screens.

Edith Evans played Irina Arkadina in *The Seagull* on the West End in 1936. Her son Konstantin Gavrilovich stages his amateur play before her, his actress-mother. He finishes, and Chekhov indicates: A PAUSE.

Miss Evans paused, it is reported, for *four minutes* before she spoke, holding the audience immobile, waiting to see her reaction. One can't do that in a film. (Although the French, it seems, won't leave off trying.)

The theatrical interchange is magic. The audience reacts as one. In the presence of artistic talent they react to the intent of the artists, in its absence, to the desire to go home.

* I approve of phone sex on economic grounds. And I think Milton Friedman would have, too. For consider: whatever the cost per minute, it must be cheaper than years of Freudian analysis—a similar experience of sitting in the dark and talking dirty.

The task of the playwright has nothing to do with that of the novelist or essayist. To hold the audience's attention, he must inculcate in them a burning desire to know *what happens next* (see Edith Evans) and must do so without their becoming aware of his actions. In this he is like the magician, whose most useful tool, distraction, can only function if the audience thinks their attention is under *their* control. The mind balks at the suggestion "Look there," but it can be manipulated if we understand its operations. It will always turn to the most interesting, shocking, or forbidden thing.

If, for example, a dog used in a previous effect wanders (supposedly by accident) onstage left and is caught by a stagehand's hand, the magician, across the stage, has had enough time, unobserved, to disappear most anything.

Hemingway tells us, in *The Dangerous Summer*, that his matador friends describe the progress of the bullfight as "instructing the bull." Every move, that is, exists to tire, weaken, anger, and confuse the bull into maneuvering into that state and position where he may be dispatched.

So it is with us playwrights. Every line, proposition, act, and scene must exist to lead the audience, increasingly, to wonder at the possible resolution of the hero's dilemma, leaving them, finally, with but a single inescapable possibility. Which inescapable conclusion (at which they have arrived, they think, through their own intellect) is revealed, at the denouement, as incorrect.

The *correct* conclusion, in the perfect play, must be clear and acceptable not only to the hero but (and only for that purpose) to those he represents, the *audience*. They must, then, in reviewing each clue, conclude that the correct answer was before them all the time and that they have, thus, been treated fairly. The playwright, that is, cannot introduce evidence which was not previously known ("Because, you see, I am your long-lost mother," et cetera).

Film is manipulable. All films, theatrical or documentary, are confections of their director and editor. That is the nature of film: the plot

is conveyed, and thus the audience's interest created and sustained, through a *succession of images*.

Film does not and *cannot* "capture the performance." It *is* the performance. Of the skill and intention of its constructors. The magnificence of the theatrical interchange is that it *cannot* be captured. It must be experienced *that* night, as part of an audience. You had to be there.

When you were "there" at a work of art, you had seen something. Perhaps we may have that chance again.

RAINY DAY FUN FOR SHUT-INS: XMAS 2020

❧ ☙

It was said that the Wright brothers, more than being the masters of flight, were the masters of preflight.

That is, they were endlessly meticulous about tuning and testing their machine's components to the limits of then-available measurement.

The dramatist's concern is not preserving life but making a living. Like the aviator, when he puts on a new play, he is, financially, "playing for all the marbles."

The play might have taken him days or years to write, but, once staged, with his name addended, it will live or die dependent on its first reception.

The wise playwright, then, will previously test each component for efficacy to the limits of his ability.

The lines, scenes, and acts are tested, first, by his diagnostic abilities. That is, he imagines himself in the place of his *audience* and gauges their imagined reactions.

He then must try his piece against the actual public, in out-of-town tryouts, invited readings, and dress rehearsals.

Only when he's tuned the piece to the limits of his ability will the rational playwright loose it on the world.

The author's analysis of his play is a diagnosis: he must now apply specialized skills to determine what is wrong with it.

The intern takes an hour over the patient's history, the skilled physician five minutes.

Like that physician, the playwright, educated in the school of shame and failure, is interested *only* in that analysis which will allow him to avoid them.

He is not concerned with those symptoms that occupy the layman: character, setting, "backstory," tone, and so on have as little meaning for him as do the extraneities to the physician. Like the physician, the dramatist must learn *not* to listen to embellishments of the ignorant and to ignore the promptings of the ignorant and weak portions of his character (for example, "A little bit can't hurt").

For it is, of course, the "little bit" of extraneity that kills the piece: the audience, until its appearance, was borne along watching a magic trick. The magician can pause to explain where the trick was learned, but the audience to which he returns will not be that which he left.

The work of the dramatist, analyzing a play—his own or that of others—differs from that of the psychoanalyst's dissection of a dream in this: the latter's analysis (for whatever it's worth) is performed in aid of the patient. That of the dramatist, in aid of the *dream.**

The dramatist's dream, his creation, must take on a life independent of its creator. It must, that is, begin to assert itself in ways which *he did not foresee.* Only by accepting these excursions, in the process of creation, can he determine *the presence of the outliers* that, alone, will reveal to him the unforeseen, essential nature of his composition.

Here is an example:

Two wartime British films examine the trauma of marital separation. *Vacation from Marriage* (1945) stars Robert Donat and Deborah Kerr. They are a miserably married prewar couple. She is a sniffling hypochon-

* Or, in Freudian terms, to reason from the *manifest* to the *latent* dream.

driac, and he is a prematurely aged, humorless bank clerk. War breaks out, and he enlists in the Royal Navy, she in the Wrens (Women's Royal Naval Service).

He rises, through the war, to become a battle-hardened chief petty officer, and she, a decorated commander of a harbor boat. After the war they come together, each determined to break off the humorless, dreary prewar marriage. They are, then, reunited as the newborn human beings they have become.

The companion piece is *The Years Between* (1946), by Daphne du Maurier. Here the couple are Valerie Hobson and Michael Redgrave. He goes off to war, and she stays on the estate with the spaniels. He is reported dead; she mourns and wants to die. Eventually, she is brought back to life by the suggestion of an old friend that she run for her husband's seat in the House of Commons. She does so, and wins.

She rises to power in the House as a champion of women's and workers' rights. She is admired, respected, and beloved.

Her husband's best friend, having waited a decent amount of time, proposes to her and she accepts. On the eve of their wedding her husband returns. He's spent five years, she is told, in a prisoner of war camp.

We all (my wife, myself, and our two poodles) wonder how it could possibly end. We cannot, for all our diagnostic skills, beat the writer to the ending. Hobson decides to fess up (after all, she is not at fault) and marry the new chap. Her comforters, pro and con, drive her mad with advice. Then she asks her husband why he didn't write from his five-year-long imprisonment. *He* explains that he wasn't actually in a prisoner of war camp at *all*. The War Office had sent him on a secret mission into Badland. He knew, when he left her, that she would be informed he had died. But his commanders decided she could not be trusted with the true information.

This is cheating by the writer.

She is introducing a late-occurring and patently false assumption to "veer" the story around a bit. Du Maurier figured, consciously or not, that in order to throw a wrench into the audience's prognostications, a

new element was needed. Hobson is devastated by Redgrave's duplicity (for all it was for king and country); he has put her through hell and then returned, on the eve of her wedding, to announce "just fooling."

It was intended that the audience use this out-of-left-field info to *turn against* Redgrave and to give support to the opinion that Hobson should leave him.

It is a cheap and unsatisfying move. She *does* decide not only to leave him but to surrender back to him his seat in the Commons.

Having decided, she is, again, turned around by the chorus: Nanny, played beyond perfection by the great Flora Robson.

Robson gives the "Joe the Explainer" speech. She announces that she, too, lost a man, at the Somme, in World War I; that so many women, for two generations now, have lost men; and that Hobson and Redgrave should thank God they have each other, forgive, and forget, and go on together into the new thing of the postwar world.

Hobson then sees the light. She and Redgrave are reunited in love, and the last shot shows them, across the aisle from each other, each now a member of Parliament, though for opposing parties.

It's been said that a drinking problem is like a little Latin: if you've got it, sooner or later it'll come out in your book. Likewise du Maurier reveals herself, and her understanding of the piece's falsity. The final shots, in a romance, show the couple finally united or reunited. The shots here show them as happy political opponents.

We might ask why they are opposed, or, to be "mechanistic," how Redgrave magicked up another seat from his borough. Yes, it is a convention, but why is any convention required?

The other dead giveaway is in Flora Robson's speech counseling conscience. She speaks of all the women who sent their husbands off to the wars, knowing many would not come back, some wishing they would *not* come back.

It's a stunning line, and the confessional key to our analysis. For,

because the film's ending is false, we must assume that the *essence* of the struggle is misstated. (The ending is the culmination of the struggle. If the film's punch line is that they are happier being apart, the drama must be re-understood as the struggle to adopt that conclusion.)

After receiving the War Office's death telegram, Hobson goes to pieces. She mourns and spends evenings addressing her dead husband, whom she imagines as a ghost, still in his wingback chair.

His return and his obstinate selfishness must be excused, then, because of "what he suffered" in prison camp.

The revealed strategic lie of prison camp must be accepted because it aided the war effort. But it doesn't make Hobson happy, only dutiful.

But if we reorder the elements, and remove the weak buttressing, we find this: Hobson, like the women in Robson's speech, finds she is *happy* her man went off to war.*

On his return, she learns that rather than being either dead or imprisoned, he was having the time of his life playing Scarlet Pimpernel.

The true ending of the story—that is, one which runs, without deviation, from the precipitating event (his departure) to the end—*must* be that the now-healthy woman leaves him and continues the life she created for herself during and due to his absence.

Is this a happy ending? It is the true ending.

The film might end with Hobson driven mad by a terrible choice and killing either herself or the husband whose duplicity has brought her to madness.

And they might be reunited *miserably* (for example, an epilogue scene of her descent into drunkenness or adultery), but they cannot be happily reunited, and the writer knows it.

That which might be presented as a story of independence, or of the tragedy of wartime, is fondly warped into a worthless romantic comedy.

* Robson, Nanny, is, as always with the maid, the chorus; that is, one aspect of the hero's consciousness, extrapolated.

The unfortunate glut of Christmas films offers little straight-up entertainment, but a heap of material for exercise of my hobbyhorse: the stunning efficacy of the repressive mechanism.

Christmas films divide into the religious/historical (the beach boy Jeffrey Hunter portraying the Essene rabbi Christ) or, in the vulgate, films about Santa.

Here, the pagan celebration of the solstice and the Christian adoration of the savior are replaced by wish-fulfillment fantasies: those who "believe" strongly enough will have their (always mundane) wishes granted. In effect, each will get his sled or her scarlet ribbons, awarded by angels, ghosts, elves, Santa, magic reindeer, and so on. This is a celebration of propitiatory prayer, a practice found by any who have attempted it to be educational.

But there are instances of *unspoken* prayers answered.

I cite *A Christmas Carol*, the best example of the dramatist's weakest strategy: "And then they all woke up."

Albert Hackett and Frances Goodrich rewrote it as *It's a Wonderful Life*, Capra's 1946 film, the story, here, told from the viewpoint not of Scrooge, Lionel Barrymore, but of his downtrodden employee, Bob Cratchit, Jimmy Stewart.

In the Christ story, He is born, suffers, and dies, but we'd better watch out, indeed, for He will be back. Which is the punch line of *that* tale.

The Hacketts also took an adolescent girl's diary and raped it into *The Diary of Anne Frank*, a sitcom.

As a supposed sop to the Jews, and Jewish anguish, it is merely worthless. But its worthlessness and simplicity may be fully understood as something deeper by reference to its closing line.

The Frank family, you will recall, have been hiding from the Nazis and squabbling about "whose turn it is to feed the cat." At the end, the Nazis show up to take them all to their (offstage) deaths.

The Hacketts' play ends with Anne's line: "I believe people are still good at heart."

I'd always considered this merely loathsome twaddle, but if there is

any truth in these Christmas meditations, I must consider the tagline as probative.

For whether or not the line was scribbled by Anne Frank, the Hacketts adopted it as the punch line for their play, that is, that by which they wished their vision to be remembered.

But the line brings to mind that of Joseph Goebbels. Addressing the Gestapo, he said, "History will note that we did these things while still preserving our essential humanity."

The Hacketts' line, similarly, can be understood as "These monsters are basically good at heart, despite what they have done to the Jews."

The ignorant director or actor asks, in rehearsal, "Given these lines of dialogue, what might I imagine or invent about the character's childhood?" His wiser colleague does not ask the question, because the character is only black marks on a white page. There *is* no childhood to examine.

The analysis of dreams can be either a sort of necromancy or a parlor game.

Dramatic analysis and construction are one and the same. To be useful, they must approach closer to the rainy day activity (Scrabble) than to the analyst's couch.

For to have a useful answer, one must ask a useful question. That question for the dramatist is this: Given the facts which present themselves to me (the elements of his composition) independent of the fact that they come from my unconscious, how can I now *disregard* their associations (What does it make me think of?) and assemble them into a logical progression (What word can I make from the letters?)?

One may not, of course, cleanse all perceptions of associations and the emotions they produce (satori), but one may try.

The story of the Christ is reimagined as the myth of Santa Claus, and, that being insufficient to cleanse the story of awe, and any attendant responsibility for action, is again denatured as a happy celebration

of magic reindeer and snowmen, "Season's Greetings" replacing "Merry Christmas" in the Western vocabulary.

Here is the tell (the giveaway): Why should this be the only season that requires greetings? The dramatist, asking the question, learns that something is being hidden (repressed). He may then, properly grounded, profitably proceed to further inquiry.

Give My Regrets to Broadway

---✶✶✶---

For fifty years I've paid my rent by getting people into the theater. There are several strategies for doing so, but from the first I've relied on the most effective I know: be good.

If the play is provocative, interesting, funny, sad, or diverting, it is possible that the people will come. It helps to have a notable cast, and it helps to have, if not the actual endorsement of a friendly, the inattention of a hostile press.

But, finally, my party turn was "being good." It was not an infallible technique. And the audience and I sometimes differed about its definition. I did, however, know one certain way to keep them away: tell 'em the play was good for them. Few, however gay, will attend a wretched play merely because it is about being gay.[*] Gay people don't need anyone to explain to them what it is to be gay, and Blacks, being human, will not likely go to a bad play merely because it is about being Black,

[*] Here the issue play is like the dramatic biography: if the drama is boring, it doesn't help that the main character is George Washington; if it is *enthralling*, it's not necessary.

or written by an African American. Who might attend these hectorings called dramas?

Some, of course, attend the theater as, once, folks, in search of enlightenment, agreed to be bored by slides of the Holy Land. And today there are, probably, in various cities, as in the onetime capital of the world, those who will drag themselves or others to a pediatric lecture on diversity, but not very often and then only those past the approved age for excitement.

The young and productive, the vital, in short, may still inhabit SoHo or Echo Park, but they do not go to the theater. Why would they? For a "rollicking frolicking evening of inclusion humor"?

Just as the surest way to drive a potential audience away is to invite them to take their medicine, the most effective way to get the asses in the seats is their understanding that "you can't get a ticket."

Seventy-five percent of the pre-hysteria Broadway audience were tourists. Out-of-towners traveled to see *Hamilton* because "you couldn't get a ticket," but, *Hamilton* aside, who would spend a vacation and ten? twenty? thousand dollars on a New York theatrical trip where the only fare on offer was but an endorsement of right thinking? Tourists may come to New York to see musicals and enjoy the pageant. But who would devote his vacation to sermons—that is, to the current spate of pseudo-religious drama? The most ancient theatrical adage is "don't sell cancer." "Issue" plays (and what is a less interesting issue than diversity?) can attract only those on a pilgrimage.

Idiot Caucasians may attend such plays as devoted Catholics once journeyed to St. Anne de Beaupré, in Quebec, to knee-walk up the myriad steps in an act of penance and propitiation. Those who rose from those prayers refreshed had had their prayers answered. But what is the prayer of those torturing themselves with the fatuity of issue plays? They might have enjoyed an evening of ratified arrogance, but they did not rise from their seats in increased understanding or (as is the real purpose of the drama) in gratitude for a two-hour reprieve from their wretched

self-absorption. They leave the theater exhausted and, unable to assert it, devoted to a joyless and hypocritical self-congratulation.

Theatrical pedants now groveling in diversity once devoted their lives to pointless exegesis. For example, Hamlet: O, that this too too solid flesh would melt.

A pastime for four hundred years of scholarship: Did he mean "solid" or "sullied"? Q. What difference does it make? It makes none to the audience (who could not even *hear* the difference), but such concerns were the rice bowl of talentless and tone-deaf pedants, letting them, to their minds, sit at the head of the same table as Shakespeare.

Today, one after one, beloved classics of Western thought are trash canned because of the race, sex, or purported sexual preference of their creators.

This brings to mind the British laws against homosexuality. These were not repealed until 1967 and were known as "The Blackmailer's Charter." Today's diversity police are similarly enfranchised brigands, levying tribute on a different populace, that of the theatergoer. To the unconvinced I suggest a test. Say to one just returned from and praising a celebration of diversity, "Quote me a line."

American culture is now dominated by envenomed prigs.

Mass media sell subscriptions, which is to say "content," which is to say "sausages." The subscriber, having purchased a package, is now deprived of further choice.

But that is not how human beings, *given a choice*, elect our entertainments.

For though it is incontrovertible that cold broccoli is better for one than hot chocolate mousse, where is the restaurateur fool enough to advertise the former in the hope of attracting customers?

Straight drama on Broadway will reemerge as morality plays— audience choice, in effect, banished; for the classics will have been expunged, and current offerings will, finally, be only "content," just like television.

The content of television shows is essentially undifferentiated. Not only are all the cop shows interchangeable; they are interchangeable with the medical shows. (Swap out the shoot-outs and the ER scenes—the action sequences—and they are all just bad narration about offscreen characters.)

As invention and insight are banned, only those individuals (a) on the approved list and (b) content to write propaganda need apply.

Now, with the straight play dead, and tourist audiences skipping the sermon, producers will observe that only musicals and pageants can "rope in the rubes."

Broadway, then, will have become an amusement park, drama and comedy superseded by content, which has then given place to drivel, and tourists may come to be force-fed entertainment as we travel to Mount Rushmore, a once-sacred place desecrated by political wickedness.

BROADWAY

Frank Case wrote *Tales of a Wayward Inn* (1938). It begins, "A busboy managed to buy New York's Algonquin Hotel. Here's how I did it."

The Algonquin was the HQ of the Round Table, wags and wits of 1920s and 1930s New York. We will mention Dorothy Parker and Robert Benchley, the closest of friends and a great comedy duo.

Some newcomer to Broadway saw them at a party and said of Dorothy, "That would be Mrs. Benchley," to which Alexander Woollcott replied, "It would, except for Mrs. Benchley." Benchley can be seen doing his magnificent bumbling routines in various films (*The Treasurer's Report*, *Sex Life of the Polyp*, etc.).

I idolize Benchley as one who would stop at nothing for a gag. The Round Table was playing Murder that year. In this game, we know, one of the group is chosen by lot as the murderer. The chosen, at discretion, winks at a victim, who is then "dead," and it is the group's task to deduce who is the assassin.

Well, the game went on, and now this and now that one fell. The group was going out to East Hampton for the weekend, and Benchley regretted that he had a lousy cold and would have to stay at home.

He asked a friend to phone him, at his Manhattan apartment, when he'd arrived on the island and report on any new developments in the game. Benchley answered the phone, coughing and sneezing, and the friend said no one had yet died. Benchley said he was going to take a nap and asked the friend to call back in three hours.

He hung up, ran downstairs, and took a cab to the East River, where a waiting seaplane flew him out to East Hampton. He waded ashore and crept up to the house that held the party. He waited at the window, outside a bedroom, and when a friend entered, he knocked on the window. The friend looked, Benchley winked, and the friend died.

Benchley reversed the process and was reentering his apartment when the phone rang. He answered it, groggily, and was told the murderer had struck again.

I knew the Algonquin thirty years later. The Round Table were long gone, but in the 1970s the hotel retained some theatrical cachet. Audrey Wood, who'd been Tennessee's manager, lived across the street, at the Royalton. I had tea there with her, and that was certainly *some* connection. Don't we all dramatize (warp) our pedigrees? Of course we do. One generation to deny, a subsequent to assert, the presence of the horse thief.

So there I was, in the dining room of the Algonquin, in 1970-something. A good-looking man in his forties was sitting with two very beautiful young women. And he was lighting Shabbos candles and praying the Hebrew blessings. The waiter told me it was Leonard Cohen, and I thought, "He's making it tough on the rest of us"; that is, "Must he do it in *public?*"

I was then, mercifully, somehow moved to examine the enormity of my thought, its cowardice and self-loathing, and the examination brought me to reexamine Judaism. (Leonard told me, decades later, that the beautiful young women were his daughters.)

Broadway, for decades, was the center of that major part of American culture that was Jewish, as much so as the Stroll, 1920s State Street Chicago between Twenty-Sixth and Thirty-Ninth, was the Broadway of Black America.

I first saw Broadway north of Seventy-Second Street in the 1960s and was stunned, for, though I had seen a Jewish enclave, I had never even imagined a Jewish city.

But to recur to the Theater District.

I recall the unspeakably louche atmosphere of Broadway and Times Square in the 1970s. It seems to be the case that when the reformers take over, the town dies. They are not the cause but the inevitable concomitant of an enterprise that has lost its vitality.

Times Square, Broadway, and Seventh Avenue were then the domain of the hustlers: the pool halls sold anything one might desire—or, indeed, unfulfilled promises of the same. I often met the Murphy man on Eighth Avenue—the Rialto of peep shows and massage parlors. In this ancient scheme, a con man approaches a likely victim and promises to steer him to a prostitute for a fee. The mark follows the Murphy man to some apartment door and is told, "Give me your money and go right in." The money's handed over, and the Murphy man disappears.

And I'd often watch the three-card monte games played on the street.

The monte gang sometimes held ten people or more. The lead performer was invariably a Black man who was "tossing the broads" on a cardboard box. "Three queens—one red, two black—red you win, black you get back, twenty get you forty, forty get you eighty, eighty get you a little lady."

As my friend Ricky Jay said, "Three-card monte is not a game of chance, three-card monte is not a game of skill, three-card monte is not a game."

The mark is given the chance of doubling his money by picking the right card. The gang contained lookouts, shills, who "win" at the game, and "spear-carrier" members posing as tourist onlookers who report, of the monte dealer, "I've been watching the fellow for ten minutes, and he hasn't won yet."

The shills were invariably white (to appeal to the invariably white victims) and, in a progressed and brilliant development, often portrayed Scandinavian tourists. I got punched in the mouth at a three-card monte

game when I, "hep to the jive," picked the (to me) obviously correct card, the admonition proving that I was, in my own chosen way, just another mark.

Sardi's had long replaced the Algonquin as *the* restaurant of the theater crowd. In the 1970s it was run by Vincent Sardi, son of the original owners, who'd founded it as a speakeasy. Mr. Sardi always called me Mr. Mamet (I was in my twenties) and saw to it that, as a playwright, I was treated as a personage.

In 1977 we held the opening night party there for my play *American Buffalo*. It starred Bob Duvall, Kenny McMillan, and John Savage, and it was some show.

Brilliant opening night. The cast went to Sardi's for the traditional party and the reading of the reviews. One after another came in and was a rave. But the mood was restrained, and my father asked why.

"Well," the producers explained, "the only one which counts is that of *The New York Times*."

"Hold on," my dad said, "this one review could close the show?" And the producers nodded sadly.

"What did the show cost to put up?" my dad asked.

"Seven hundred thousand dollars."

"What does this *New York Times* reviewer make in a year?" he asked.

"Perhaps thirty thousand dollars," he was told.

"Are you *nuts?*" my father said.

Broadway's imprimatur was awarded by Sardi's placement on the dining room wall of a caricature of the newly ennobled. They did one of me.

The same building held the offices of the Dramatists Guild.

Members of the guild's board met there once a month or so to discuss matters great and small. I was elected to the board in 1980. Other members included Stephen Sondheim, Arthur Laurents, Lillian Hellman, Edward Albee, and Marc Connelly, then ninety years old.

I saw them all there, save Miss Hellman. I can't remember much we discussed.

Here's one exception.

Gerry Schoenfeld (1924–2008) was then, with Bernie Jacobs, head of the Shubert Organization. In 1982 the Shuberts wanted the approval of the guild for their plans to tear down a couple of historic Broadway theaters, the Helen Hayes and the Morosco.

Gerry showed up with artistic renderings and the magic word that licenses all things: "progress." He gave his presentation. And I said, "Mr. Schoenfeld, are those theaters owned by the Shubert Organization?" He replied, "No, they are not."

"Well, then," I said, "you want us to endorse your plan to destroy the theaters of your competitors."

Pause pause pause.

"Who are *you?*" he said. "You can't even write a *play*."

"I may or may not be able to write a play," I said, "but when you think you can make a buck off of me, you'll kiss my ass in Macy's window."

Much huffing ensued.

Gerry and I later became friends and got a kick out of each other. I miss him. I doubt today I could *get* my ass through Macy's window. Perhaps after the next rioting.

I had friends in the box offices of Broadway, many of whom got very rich indeed from "ice."

This was the (legal-adjacent) subversion of hit show tickets to ticket brokers.

Broadway was, then, limited by law from inflating the ticket prices of popular shows.

The theaters could not do so, but ticket brokers (legal scalpers) could.

It might even have been that someone paid something to someone

who gave something to one who voted in the legislature. I am not saying it was so, but if not, it would be the sole exception in the history of New York State.

In any case, the box office managers sold blocks of tickets to the brokers.

The ticket, let us say, sold for twenty dollars, but the scalpers would pay the box office guy a premium of ten and sell the ticket they'd bought for thirty to a tourist for whatever it would fetch.

Now, the box office manager would pocket ten bucks times twenty tickets a show equals two hundred, times eight shows a week equals eighty thousand tax-free dollars a year. Pretty cute.

But what in this life is on the level?

We might say the love of a dog, and we've seen the bumper stickers "I wish I were the person my dog thinks I am," but after a lifetime on Broadway I've come to think that all slogans exist to take advantage of suckers and that often the intended sucker is oneself. A more advanced understanding of the slogan might be "I wish I were the person I *think* my dog thinks I am." The addendum crediting the beast not only with compassion but with a duplicity indicating intelligence.

On the level, on Broadway, was Delsomma restaurant at Forty-Seventh Street, just east of Eighth.

I was welcomed there, as a regular, by the owner, John Cardinale. I did the mafia comedy *Things Change* in 1988 with Joe Mantegna and Don Ameche. I asked John if he'd come out to Tahoe and portray a mafia chief, because, to my mind, he looked like one.

He came, and you can see him in the film. And I later learned that John had been a protégé of Albert Anastasia's. During the war he'd been a Seabee. He shared with me their motto "The marines make some landings and the army makes some, but the Seabees make them all." I was crazy about him.

I'd always invite him to see my shows, and he'd always respond that he "might just do that." I said let me know if you need a ticket, and he'd nod, gracious to the naïveté of one who didn't know that he was the

éminence grise of the stagehands and the allied tongs. How I mourned the passing of that restaurant, and may he rest in peace.

West of Ninth Avenue we had the Actors Studio, and homage to it in the title Studio Duplicating Service.

The latter printed all the New York scripts. They were run off on mimeograph machines (look it up) and bound in thick cheesecloth covers with the play's title and the author's name impressed in gold.

Strasberg's Actors Studio was on the same block. I was never inside the Actors Studio, though I knew or was friendly with the other luminaries of that acting-as-an-expression-of-Freudianism era: Uta Hagen, Herbert Berghof, Stella Adler, Sanford Meisner (my teacher), and so on.

I always admired Lee Strasberg as the King of the Hucksters: he gained a position as the Dalai Lama of all gurus, and the most talented of actors vied for admittance. When they became prominent, he took the credit. As if the promoter of a swimsuit competition took credit for breeding the young things.

There was Studio Duplicating, and the smell of ink through long afternoons proofing my plays; Forty-Seventh Street, Joe Allen's, his burgers within the reach of the employed, and the smell of cheap beer around the corner at various taverns. Cigarette smoke hung over everything, as did pollution. It felt dangerous because it *was* dangerous. And to be young was very heaven.

We all lived in fifth-floor walk-ups (some must have lived beneath the fifth floor, but I never met them); the Murphy bed folded down from the wall, and the bathtub was, indeed, in the kitchen, and covered with a board to form the kitchen table.

Students (I was one in 1967–1968) could second-act any show on Broadway. I recall Sandy Dennis and William Daniels in *Daphne in Cottage D*. I remember nothing more, until, some years later, my agent Howard Rosenstone and I went to a dress rehearsal of Ira Levin's *Deathtrap*. It fell flatter than Olive Oyl. We tried to philosophize with the distraught

author, with the timeless "you'll write another one." As indeed he did, while *Deathtrap* ran for two solid years.

I recall Bob Duvall as Teach in my *American Buffalo* at the Ethel Barrymore, opening thirty years later on the same stage as *Streetcar*.

Many in the *Buffalo* audience jeered (the play contains not a lot but nothing *but* profanity), and at the curtain call Duvall gave them the finger and began kicking the detritus of the last act into the audience.

I recall the summer of 1967, when many of us slept in the all-night air-conditioned porn theaters of what is now the Disneyfied Forty-Second Street.

It was a circus, and like any circus, when it goes legit, it's over. And now, it seems, the other shoe has fell.

The golden age of Broadway, an organic theater, supported by a devoted middle class, became the new thing in the last thirty years, as production prices rose, ticket prices kept pace, and advertising became prohibitively expensive. At the same time, the middle class, the audience whose custom was the basis of Broadway's life, was priced out of the city.

Broadway became the site of musicals and pageants, geared to the tourist trade.

Now the remaining middle class has been rioted out of Manhattan, and no one knows when, if, or why the tourists will come back.

The age of sail coexisted, for a moment, with the growth of steam, and then only in the memories of those who'd been there.

The last of the cowboys on the cattle drive died in the 1950s. Broadway died last spring.

It may, like Lazarus, be raised from the dead by a miracle, but, again, as in his case (for the Bible does not say), we cannot know in what way the resurrection might affect its operations or its mood.

GAGS

The film genre screwball comedy does not, in fact, exist. There were a hundred efforts to capitalize on the works of Lubitsch and Preston Sturges, but most coasted on the form, stole the plots, flagged the places where the gags should have been, and had the actors falling down or spilling soup on one another.

The few great 1930s comedies had a simple plot, following the wisdom of Sun Tzu: let your plans be simple, so that your opponent can follow them. The great comedies moved the *plot* along by great gags.

What is a gag? It is a joke requiring, as all jokes, a setup, a development, and a surprising punch line. It must unfold *over time*, that is, calling to the audience's attention some facts that they, previously, noticed but did not feel important.

In *Some Like It Hot*, the genius comedy of Billy Wilder, the two musicians witness the Saint Valentine's Day Massacre. Jack Lemmon's bass fiddle gets perforated by machine gun fire. He and Tony Curtis flee to Florida. The Mob comes to vacation in Florida. Lemmon and Curtis are incognito as women musicians. But then the Mob chief spies the perforated bass, and the jig is up.

In *Unfaithfully Yours*, by Preston Sturges, Rex Harrison plays the conductor of the world's most famous orchestra. He refers to himself as "a bandleader." Not a gag, but a pretty good bon mot. Similarly, with a semi-excusable (and factitious) attempt at self-deprecation, I've always referred to myself as a gag writer. My "straight" job description, for the last millennium, has been "dramatist," but the term made me queasy.

The honest lawyer (pause) may refer to his profession with affectionate deprecation as "mouthpiece," and it's funny because there is much truth therein. A gag writer who can structure the small bits into a plot that holds the audience is the real thing. Those who cannot may be called dramatists, but I ain't going to see their play. Aristotle referred to those components that constitute the plot as "incidents," but they're just gags.

Now, the essence of a gag is that, ex post facto, it becomes self-evident.

Q: What do you call a Black man who flies a plane? A: A pilot.

The writer stumbles upon, or perhaps over, a great gag; for it can't surprise the audience unless it surprises its creator. Frequently, the thing seems so inevitable that he wonders if it is not actually known to all and he's the last to hear. All comedians know the phenomenon: we come up with a gag so good we stun ourselves and have to call our friends to ask, "Did I make this up?"

Here are two examples from my own oeuvre: referring to the political process as "wag the dog"; and a line from my film *State and Main*. Alec Baldwin, drunk, wrecks a car in which he has been canoodling with an underage girl, Julia Stiles. He drags himself out of the car, looks around, and says, "Well, *that* happened."

I am often baffled in writing drama. But if the dramatist is not, at some points, lost or confused, he is not doing his job; for the journey of the

writer and that of his hero are one and the same. Both are forced to make difficult choices. Based on what?

When at a loss, the dramatist may step back, refer to basics, and ask, "What is the *form?*"

Gang comedy, slapstick, farce, comedy of manners, exist *as forms* because they correspond to various human modes of understanding.* We may refer to examples of the form to determine our requirements as writers: romances end in marriages, comedies in return of the heroes to the situation per ante, sadder but wiser.

If the piece is a farce, we must find the stock characters; their presence defines the form: the stern father, old lecher, prating professor, mooncalf lover, mean miser, and so on. The comedy of manners must contain a butler or maid acting as the chorus; a melodrama has to have a vile villain.

Civilizations and constituent societies progress through recognizable forms. The upheaval of the last few years can be identified as a nascent totalitarian movement by the accretion of religious rites, observances, miracles, and martyrs.

The new food laws are strict as halal and kashrut and considerably more elaborated. See locally sourced, gluten-free, cruelty-free, free range, organic, fair traded, sustainable. (My jar of peanut butter carries the warning that it was processed in a facility that might have processed peanuts.)

An insistence on pansexuality has replaced previous injunctions to chastity with an equal vehemence; vagrancy is redefined as a sort of martyrdom; disorder is celebrated with that pride once reserved for examples of restraint; and "the peace which passeth all understanding" has given way to an insistence on the constant performance of rage.

* As the 35 mm lens most closely corresponds to our natural field of vision.

• • •

For the last few years, I'd wondered how the Left could burgeon as it did as a political-religious entity without a name and without a leader.

Just as one needn't worry on an airplane until the flight attendants do, I consoled myself that things would not progress into actual insurrection until the Left confected the necessities above.

Now the Left has had, for the nonce, the names antifa and Black Lives Matter. And, having adopted the form, it will find it easy to change the substance, and a new name will emerge as required—just as "Bolshevik" was replaced by "Communist." But what of the leader, that person to whom they could ascribe superhuman powers, whose every action and utterance strengthened their cohesion?

The form—insurrection—required a leader; its absence drove me to the familiar writer's posture of shaking my head over a situation that *must* but *would not* resolve. And then the thing became clear. For the last six years the Left has *had* a leader, his supposed omnipotence equal to that of Hitler, Mao, Castro, and Stalin, one to whom all attention must be paid. His name ever in our mouths.

For the last six years, Donald Trump has been the leader of the Left. They couldn't find anyone on the bench to send in, so they chose the rival team's most powerful player and instructed the faithful that it was opposite day.

Human beings are herd creatures and, knowing ourselves weak, fear isolation. Each is aware of the insufficiency of his own reason, strength, and courage. The toddler invents an imaginary friend, and the psychotic hears voices.

Primitive humans were awed at the power of the weather and the sun. Their observations led to agriculture, and navigation, and the first sciences. But science left an unresolved remainder: what was chance, and randomness; how could human behavior withstand, let alone influence, the irresistible forces of water and wind, fire and plague? Every society

evolved a system that, benevolent or oppressive, substituted a group-*specific* anxiety for a generalized terror.

Humans worshipped and sacrificed to idols to ensure good crops, long life, freedom from conquest—in sum, a mitigation of the terror of powerlessness. Service to these idols, in whatever locale, was rewarded intermittently by security, health, and plenty. In their absence, failure was ascribed to insufficient sincerity, sin, or the perfidy of unbelievers. (Evil spirits, witches, the racially or politically depraved.)

Judaism, and then its daughter religion, replaced idol worship with monotheism—that is, with devotion to an *unknowable* deity. His works and notions could not be understood. He could not be propitiated with sacrifice, but service to His laws, we were taught, though they did not reward propitiatory prayer, brought peace.

And it brought about Western civilization.

It was, it seems, inevitable that "freethinking" would lead to atheism, but who would have thought this enlightenment would devolve into savagery? Anyone who has studied the Bible.

The Israelites became appalled by their freedom from slavery. And so they cast and worshipped a golden calf. The story tells us that these apostates had actually *seen* God part the Red Sea and destroy their slave masters. And then they became terrified of their freedom and denied His existence. The Five Books of Moses are the tragedy of the Jews, who found the security of slavery preferable to self-direction under the will of God.

The Torah teaches, time and again, the calamities that befall the Jews who turn away from God. Adam and Eve are expelled from paradise; God floods the iniquitous world; He destroys Sodom and Gomorrah, Babel, and time after time the rebellious who would lead the people back into idolatry, turning a generalized fear into self-righteousness and rage against the uncommitted; this rage cheered, as always, by priests.

The priests of our new idolatry are the politicians and their

nongovernmental like who have discovered the old secret of power gained through fear of the mob.

A populace panicked by prosperity fears retribution from those forces over which it *knows* itself powerless: the sun and the sea. But afraid to hate the forces of nature it worships them.

The new animists create new saints, blessed Scandinavian children, and social martyrs. The frightened populace begins to march around chanting and prepares the way for the burning of witches, through infant sacrifice, called post-birth abortion.

These various convulsions may be considered individually, but taken as a whole, they identify the drama's form as a biblical epic.

HUMILITY

S ome hold that the Bible is the literal word of God; others that, no, it was written by someone else *of that name*.

I cannot believe that anyone who has read it could doubt that, at the widest remove from metaphysics, it is divinely inspired. The difference between the second and the first propositions seems to me moot.

The Bible connects us to the divine as its honest reading humbles us and so reveals to the honest reader his distance from the divine. Which is to say it may not establish but certainly suggests the existence of a power superior to humanity.

The denial of this distance is atheism, the vehement assertion of which is, of course, just an endorsement of God's existence: God cannot exist, because there is evil. How do I know to call it evil? Because I have an ineradicable (God-given) knowledge of what is good.

We read in the Torah of our wickedness and in the Gospels of the possibility of perfection. Each rendition humbles the receptive reader, who understands the lesson as about himself. Which, of course, it is. The Bible is that tool best capable of creating humility and so correction.

During the plague I discovered another one. I decided to move offices.

For fifteen years I'd been writing in a small town house, surrounded by my precious totems: toy airplanes, trucks, motorcycles, and so on; various photos and posters; a collection of pin-back buttons on a large corkboard (employee badges from movie studios one hundred years dead, from aircraft plants, from the 1933 Chicago World's Fair).

It was several rooms full of tchotchkes (Yiddish: *bibelots*), but I realized that I only actually used the desk, my typewriter, and a kettle for tea.

"Well," I thought, "it's time to shorten sail." And so I did, engaging in the happy third stage of the collector: search, possession, and, now, disbursement. This is the sublunary form of the imagined legacies.

"Yes," I, and likely you, have fantasized, "in my will I will leave X to A and Y to B. How they will appreciate my thoughtfulness," and similar folly. I can't break the lifelong habit of sending people books, although I realized, some time ago, that nobody reads them. How do I know? Because I don't read any of the books they send *me*. I have my own tastes and reading list, as do we all; and now here I was, boxing and discarding all sorts of literature, my solution to most of it, "make it go away."

For how many of those books I enjoyed, and even those I cherished, was I ever going to open again? Then why keep them? So they went away. And then I came to the books *I'd* written and discovered the second beneficial engine of humiliation.

I love to read. I think my taste in literature is perfect because I am happy with it.

I can't read the sea novels of Conrad.

Dickens I class with a taste for Red Skelton: I just don't get it (exempting, of course, *A Tale of Two Cities*).

I am particularly fond of twentieth-century genre writers. They have brought me a great deal of happiness over the decades.

I name Frederick Forsyth, Patrick O'Brian, George V. Higgins, and John le Carré. I've read all of their books *many* times, because they are infinitely re-readable. It's, of course, a matter of taste, which is to say that those who disagree with me are fools.

I can reread my beloved Trollope's forty-seven novels again and again

but can't force myself back to George Eliot; similarly, I'll take Tolstoy over Dostoyevsky, and give you the points.

But I can and have reread the above genre writers many times over.

I don't know what position Tom Clancy enjoys in contemporary literary criticism, the study and production of which seems to me as depraved as would a course teaching child abuse.

But the son of a bitch could really *write*.

He was a realtor, and took up the form in his downtime, and created a genre. As did Frederick Forsyth, who was a journalist and a spy.

One must say of *The Hunt for Red October*, and *The Day of the Jackal*, that it's difficult to envy success, because it's impossible to write that well. Their fantasies are the modern equivalent of those of Dumas *père et fils*.

And what can compare with the better than fairy tales of Patrick O'Brian? His sea novels the modern equivalent of those of Gulliver and R. Crusoe?

Similarly, John le Carré's Cold War oeuvre begins with his ab initio effort, *The Spy Who Came In from the Cold*, a masterpiece at least the equal of Conrad's *Secret Agent*.

God bless you all, departed and alive, for the greatest of excursions.

But there is this: skill can and may increase, but exuberance, once exhausted, is not seen again. Success, like failure, leads to failure, and inquiry about the snows of yesteryear can only be rhetorical.

It's clear to me (a fellow writer) that Patrick O'Brian did not write the last two novels credited to him. They, like *Titus Andronicus*, just don't sound like the work of the same fellow. To me they rank with Hauptmann's ladder, the rickety mess supposedly used to extract the Lindbergh baby from his bedroom. Asked if he had made it, he replied, "I am a carpenter."

It is neither impossible nor inexcusable that Mr. O'Brian dictated, sketched, or otherwise consigned to an assistant some of the drudgery of actual creation. This is no mortal sin (who believes JFK wrote *Profiles in Courage?*), and more power to him, this genius, then in his eighties.

The great Mr. Carré ran out of Cold War, and his subsequent books begin to double back, as did the last creations of Mr. Clancy: a second generation of his heroes are introduced, the offspring of the first. But where in life does the second generation, actual or invented, equal the first?

And the third, we know, is in shirtsleeves, or, in the case of us writers, ignominy. No, we get old and are free to roll the bottoms of our trousers, and no one the wiser *because nobody cares.* What is more absurd than the aged roué whose wealth has occasioned the momentary companionship of beauty?

The problem with prolixity is that it becomes a habit. Writing, which has served to fill the larder, and to delay the caustic thrall of thought, has, with the passing years, become an addiction. It may still fill the larder, and it passes the time. But, having written for decades, should one stop now, what would one do?

The second engine of humility is perusal of one's earlier works.

In cleaning out my office, I boxed my own books, and then I picked up an early creation and began to read. I wrote so much better then.

MAX THE HAMSTER

———— ⚘ ⚘ ————

I f I may, without being indelicate: my wife asked me to scratch her back.
She had difficulty in following my directions to the aggrieved spot
and suggested we use U.S. geography as a referent.

We know from S. I. Hayakawa (*Language in Thought and Action*, 1949)
that the map is not the territory. But the configuration of the Lower 48 is
a pretty good match for the human back. We have Washington State over
the left shoulder, Maine over the right, the backbone standing in for the
Mississippi, and so on.

The plan was marred in execution by my wife's complete ignorance
of American geography. She was raised in Edinburgh.

Her bafflement at the layout here is as charming as everything else
she does.

She was singing a gig, on July 4 some years back, and included her,
newly learned, "Roll On, Columbia, Roll On," by Woody Guthrie. The
verse, as sung by her:

"Tom Jefferson's vision would not let him rest.

"An empire he saw in the Pacific North-East."

Further affiant saieth not.

To return to the problem of counter-irritation: we repaired to the blackboard, which is the front of our refrigerator, and I sketched out a map of the United States, while she, enthralled, looked on. As I did, delighted with both my handiwork and my skill as instructor. This pleasure tempted me, as it has teachers forever, into elaborating the lesson beyond any immediate usefulness.

It is clear from the map, I said, that the country grew and prospered around the networks of transportation and the sites of commerce. Ships brought trade to and from the East Coast, the Gulf Coast, and San Francisco, and the cities prospered as depots for the products of and to the interior.

Canoes, then boats, then steamers worked the Great Lakes, to Rochester, Cleveland, Buffalo, Chicago; the Erie Canal and the Sault Ste. Marie; and in 1959 the St. Lawrence Seaway opened the Great Lakes to worldwide trade.

Chicago was connected by canal to the Mississippi, thus to New Orleans and so to South America and the Caribbean, in 1848. The Mississippi, the Missouri, and the eastern rivers increased the country's prosperity and the wealth and power of the seaports.

The railroads supplanted waterborne traffic in the nineteenth century, forming the eastern megalopolis and creating the wealth of Chicago, the rail hub. The great cities attracted talent, whether as culture (supported by philanthropy) or its farm team, bohemia (supported by youth and disposable income), and developed through the influx of previously close-held regional achievement; see, particularly, that African American music, come up the Mississippi to Chicago, evolving from work chanteys and laments into the blues, jazz, and rock and roll, now the music of the world. See also the creation, by several Jewish huckster immigrants, of the motion picture business in New York and then in Hollywood.

The cities were, throughout the twentieth century, centers of world commerce, and so of both the fashion and the arts springing from

disposable income and its quest for novelty and status and, as important, the cross-pollination of various groups previously divided by both geography and custom: Blacks separate from whites, gays from straights, Jews from non-Jews.

After World War II, air travel solidified the position of the cities as the creators and arbiters of cultural life, as did television; for that which was deemed news (that is, newsworthy, that is, capable of selling advertising) was chosen in New York by cosmopolitans, as were the books and periodicals thought worthy of print, and each newly essential height of skirts.

With the development of the jetliner (Boeing 707, first in service in 1958) and cheap air travel, the cities also became destinations— regular Joes and Joans showing up to see the shows and have a couple of drinks.

The railroads, as passenger carriers, died, killed by the airlines. New York, one of the world's great seaports since the seventeenth-century Dutch, ceased that operation in the twentieth century because the riverfront land proved more valuable as residential real estate than as warehouses, transoceanic air travel replaced the passenger liners, and the piers became amusement parks.

I paused in my lecture (you may recall I was explaining this all to my wife) and sat, at the kitchen counter, chalk still in hand.

"What is it?" my wife asked.

And I told her the story of Max the Hamster.

He had been my pet for a few months in the 1950s.

It was my job to change his water and to add to his food every day. I did so. But I noted that he was not eating his food.

I kept adding to the supply, as per my instructions, until I realized, one day, that he was dead.

Some parent upbraided me for not remarking, if not the animal's

inactivity, the increasing amount of food in the cage. I quipped that, yes, I had erred, but after removing the hamster, we'd have more room in the cage for each day's new food.

This led me to share my aperçu about talk radio.

I love AM talk radio. After a lifetime of that FM voice selling sad, enraged concern and wistful outrage, I'm just that happy to hear good American speech and advertisements for snake oil.

One of my favorite AM commentators, now gone, was immensely and deservedly successful. Advertising on his show was consequently at a premium. But there he was in the position of a cabdriver in the rain. Everyone then wants a cab, but the driver can pick up only one fare at a time, and so he may legitimately be maddened by the waste.

As were, it seems, the producers of this talk show.

For, as with the less productive shows, a certain amount of time was set aside each hour for ads.

I don't know what this may be, by FCC statutes, but I assume, whatever the upper allowed limit, it is being fudged, because it would be wasteful not to do so. And un-American. All right, then, at some point we return, from *x* minutes of panaceas, time-share extractions, or dog treats, and so on, to the actual program.

Then, however, the host would introduce a topic similar to that with which he left us before the commercial break.

He might say, for example, that we live in an increasingly insecure world and the Federal Reserve says this or that. Then we may perceive that this is neither news nor commentary but the lead-in to an ad for silver, or gold, or wealth management services.

We eventually return to the possibility of some content, but the host, again, employs the discussion topic as a springboard into flogging his newest books, lecture tours, and so on. Like the cabdriver, his time has just become too valuable to squander on its, now outdated, purpose.

As has the land in the great cities.

Rents on Madison Avenue, our Rue de Rivoli, have become too pricey

even for the luxury tourist trade. East Side apartments, which sold for 40 grand in 1950 and 250 grand in 1970, are now twenty million dollars, but the cost of the shoes in the shops, though it might rise from two hundred to two thousand, could not rise to twenty grand, and stand-alone shops could not pay the rent, leaving the street to vacancies interspersed with flagship stores that exist only as ads.*

The cities tried to control this—call it good or bad, it is inevitable—progression away from popular commerce through the Potemkin villages of rent control, which only meant that those lucky enough to find or canny enough to bribe their way into a cushy spot spent the money they saved somewhere else. Rent control, as Milton Friedman observed long ago, leads only to housing shortages. Manhattan Island is the prime example of a city whose success led to the banishment of its middle class and its inevitable future as an amusement park and/or a slum.

There is no way to reverse the trend of commerce, which is to say self-interest. We must all follow our fortune, and the most committed and liberal member of the California teachers' union will, on the day of retirement, likely cart his pension to a low-tax red state.

The commerce and wealth of the cities grew with their eminence as transportation hubs, but transportation became air travel; bigger planes and more air traffic meant bigger airports, farther from city centers, and longer and more arduous commutes. Car travel allowed movement to the suburbs, which meant more cars on the road and unproductive *hours* in a daily commute.

Los Angeles has the greatest concentration of theatrical talent in the world, but our theaters are mausoleums, why? After a day in traffic, no one wants to get into the car for another two hours. *Finita la commedia.*

All organisms evolve, thrive, and die. The great cities, long Democratic strongholds, have approached the problems by taxing away the

* And, latterly, to rioters, who, because they were destroying, in effect, only kiosks, ran little risk of outrage, and, thus, defense from Mom and Pop, which were now multinational corporations.

productive and, in effect, paying folks to stay there—through welfare—
or to come there to "open cities," or homeless encampments.

But this, we see, avails as little as would have feeding a dead pet.

The hamster, here, is commerce. The pandemic, the shutdown, and
the riots reveal, of the cities, the truth of that ancient bureaucratic ad-
age: don't ever take a vacation. They might realize they don't need you.

DISONS LE MOT

━━ ⟫ ⟪ ━━

My beloved Clover Park has come alive. It is seventeen acres of walks and playing fields and picnic areas. Just north of the Santa Monica Airport.

One can stroll, work out, sit on a bench and see the planes take off and land, watch the children play and the families picnicking. Here, it is always afternoon, and the temperature is "either seventy-two degrees." And, until 2013, one could meet a trainer in the park. We saw one-on-one instruction in boxing, jujitsu, and circuit training and classes in chi gong, tai chi, and yoga.

Then the city council struck and insisted that all the personal trainers register and pay the city many dollars a year in fees, which only an inbred delicacy prohibits me from characterizing as "protection." So the trainers and their clients disappeared.

The students from the local private schools were nannied to the park for exercise and games, and perhaps the schools "stepped up and saw the captain." (Chicagoan: "paid the right guy off.") And perhaps not.

In any case, the personal trainers left the park. Note, this is in Santa

Monica, where the global phenomenon of bodybuilding began, at Muscle Beach.

And we may marvel at the prosperity it created. Who would have thought that immense fortunes could be made from calisthenics, and any money at all from running, at one time thought to require only feet and earth?

But the city council, those urban Robin Hoods, drove the trainers out and with them not only the money they earned and spent here but the citizens who paid taxes for the use of the park. But, lo and behold, lately the trainers and their clients had returned.

I do not know that the city council has shown either compassion or reason, which would be unlike it. Stranger things have happened, but not around here. In any case, the signs warning the trainers off have disappeared; the fitness folk are back. And the park is alive with kids. It makes my heart glad, not only that they are out in the air, but that they are not in school.

California has the highest taxes in the nation, and our schools are ranked thirty-seventh, in what I must assume is charity. Let us consider this apparent contradiction as a solution (I don't believe it makes sense considered as anything else): the California one-party kleptocracy could not exist without the support of an ignorant electorate.

"Raised by the liberals" is the modern equivalent of "barefoot and pregnant." I speak as one who has seen four children through private and public schools of Westside Los Angeles and as one who has spent most of his life as a teacher.

I was raised in the horror of the Chicago public schools. Many of my teachers were born in the nineteenth century; the wooden desks were linked by iron stanchions and held glass inkwells. The use of the steel-tipped pen had just been superseded, but the watering can, which previously held the ink, still sat by the teacher's desk.

I didn't learn a goddamn thing. It might have helped my grades, if not my education, had I ever opened a schoolbook, but I was bored to

catatonia and ashamed of my failure to embrace the, to me, impossible alternative of pointless effort.

But outside school hours I read voraciously and was certainly better read than the teachers. How do I know? Because no one with curiosity or the love of learning or of language could have subsisted for decades pontificating about the same dull trash. Neither can they today.

Thomas Sowell points out that taking the same skills and levels of education into the free market, most teachers would earn 55 percent of their current wage. And lately the beneficent governments, in recognition of—you may fill in the blank—continued to pay them while depriving the taxpayers of the services for which *they* have paid.

Of course the Left is opposed to charter schools. They are opposed to education. Teachers are, to the Left, a protected class, which is only common sense: they are a money machine, kicking back fortunes to the party, *and* a purveyor of the essential service of indoctrination. In my youth this was called "socialization." This meant, I believe, learning to sit down and shut up and pay attention. It was difficult for me, as for you, to pay attention to that which neither interested me nor offered hope of some later gain.

But schools of today are vastly more dangerous than those of yore, because they offer both things.

The grotesqueries of "sex education" and the thrill of protest are irresistible to the young mind. How is their leisure spent but in fantasies of sex and power? And the presentation of doctrine presents, to them, the *certainty* of this future gain: that gain (earned by passivity) being inclusion—that is, exemption from marginalization, blacklisting, and attendant anathemas.* *Disons le mot.* It's time to stop routinely according to teachers the encomiums "hardworking," "dedicated," and "underpaid."

* *These* are, in fact, the "bullying" with which the Left is obsessed—not with uncovering it, but with *distracting* from their practice of it.

It takes very little time to prepare the vaunted "lesson plans," the toil of which is supposed to consume their afternoons, evenings, and weekends. And it takes no time at all to remove last year's lesson plan from its folder.

It takes little time to grade tests, and it is not taxing. The math solution is correct or it is not, at a glance, and the papers are short and, at that, need only be scanned.

Some teachers are good. Some, indeed, are an inestimable gift to the student. I have met a few, and likely you have, too. Most of these had no connection with a school but were wise and enthusiastic about conveying their insights (whether mechanical or philosophical) to those eager to learn. The beloved shop teacher or coach is remembered all our lives. Who recalls an English teacher?

Am I advocating, then, an abolition of schools?

Yes. What good do they do?

The children in the park are learning more than they would in school. *What* are they learning? *Something*. How could they not? They are mobile engines of curiosity.

They can learn to read with the help of a parent or older sibling. Having learned to read, they can learn whatever else they require.

One might ask, "How will they get a job?" But how will they get a job selling diversity, or social justice, or flogging a film school degree?* These will have to exist on some sort of subsidy. It is no wonder that the Left wants college to be free; they receive, in return, an ignorant, biddable voter.

It was said that a liberal arts education allowed the child to follow his instincts, exposed to a variety of subjects and modes of thought.

* Note: Absent instruction in technical crafts—camera operation, lighting, set and costume construction, production accounting—there is nothing to be learned there. They are an expensive charade of bohemia. There is nothing one can learn there about acting, writing, or directing, jobs that have always been open only to those willing to fight their way in and stay there. Film schools are a joke.

Everyone, during that forgotten day, knew it was a lie, but we all went along with the gag.

But even that, a fig leaf to the intellectual laziness of parents and the delighted nodding of the college-bound, is no more. No one now *knows* why children are sent to college. And, in the backwash of the plague, we may ask why they are sent to elementary school. It functions as day care, of course, and this is not an inconsiderable benefit to working parents. But if the parents would like their children, eventually, to be self-supporting, they might take a close look at the waste of twelve years of their intellectual curiosity, receptivity, and malleability.

That irreplaceable period will not return, but the habit of rote reception of doctrine will remain, indelible.

ART, TIME, AND THE
MADNESS OF THE OLD

T he writer, like the oyster, is motivated by affront. It is the indignities,
or perhaps abuse, enjoyed in childhood that shock creativity into
operation in those with that potential. Creativity may also be engen-
dered as a response to nonpersonal affronts: to confusion, for example,
or wonder.

I do not mean wonder at the world's beauty, but, rather, at its absur-
dity, cruelty, or injustice. This is very different from compassion, which
is sympathy for suffering.

Art has nothing to do with compassion. It is much closer to cruelty,
as it has no conscience. The artistic impulse is, in a literal sense, *excited*
by wrong. Just as the oyster is excited by irritation.

The talentless seem to feel a "sense of wonder at the beauty of the
world." Such may give us, at its uttermost best, the anodyne of Robert
Frost but not the poetry of Yeats.

The talentless, moved by nature, photograph the sunset, attempt-
ing to apostrophize the work of a previous creator. But the "wonder" of
the actual artist is, consciously or unconsciously, an effort to metabolize

some upset or disarrangement. The result, art, is a rearrangement of experience and perception into a new phenomenon. It is not intended to "express" anything.

For if the artist's condition and intention could be reduced (by him or by the audience) to a definitive *meaning*, the product may be propaganda, or entertainment, but it can't be art. Was Chagall trying to remind us that goats fly?

The search for meaning in art is close to the search for "closure" in human relationships, or in analysis or therapy: all depend on a predetermined conclusion and engage in a supposed train of investigation to lead the participants to it.

Now, the talentless, unaware that they lack talent, have always tried to co-opt it or explain it away. Critics, museum curators, and so on have open to them, should they accept it, a career in derogation. It is not that the inmates have taken over the asylum but that they've been removed from that position.

Artists are freaks. This means not that we are, in any way, substandard but that we are *anomalies*, random mutations thrown off by the same gene pool that produces schizophrenia and perfect eye-hand coordination.

One million chimpanzees at one million typewriters could not create the work of Shakespeare, because, probability aside, why would they wish to?

But the artist has no choice.

Samuel Beckett was the greatest dramatist since Shakespeare. See "You must go on. I can't go on. I'll go on." *The Unnamable.*

None of the rewards of art are greater than the peace of that brief moment between the completion of a task and the reception of the next command. We all ask, or want to ask, "How did it feel?" But interviews and biographies *must* be fictions; for, again, like psychoanalysis, they start with an unstated premise (art can be explained by reference to consciously understood experiences—"I wrote the *1812 Overture* because I

heard a cannon") and fill in the blanks to gratify the self or to appease, confuse, or impress an interrogator.

Like you, I receive letters, texts, and so on, to respond to which would be a burden. I also get books and plays sent for my opinion. The second is an imposition, but because I imposed similarly, when young, upon the successful, I feel bound to respond. I feel bound, but, increasingly, I shirk that duty.

Now, we all know the inspired dodge of moving the offending requests from this pile to that. After a while they lose their potency in transit. But then the sender may, and usually does, ask if we received the communication. What can one do then? One may lie and say, "I never got it," in which case they'll resend it and the trauma begins again.

One may respond to the request and get it over with, cursing the sender and the fact of one's birth. Or one may not respond *at all*.

This last has the benefit of creating in one a moment of retribution, but the defect of inflicting discomfort, pain, or humiliation upon the sender.

None of the alternatives are good, and one must choose among them. Recently, however, it occurred to me that time has come to my aid.

As we age, we become circumspect in inquiring about the situation of others. Where once we inquired after the spouse, asking a person in his forties was likely to reveal they are divorced. Asking one in his sixties, "How are you?" may produce a torrent of unfortunate medical information.

But—and here is the beauty part—one in his eighties asked about a spouse may respond that she is dead. So, decade by decade, we learn *not* to ask the pregnant question. It's a common observation, and not of much use *except to me*. For I realized that I need not respond to *any* trying communications, because the sender might conclude that I had died. That is putting an understanding of time to good use.

So much for time. What is the use for art? It has *no* use. No more

than a sunset. But today I was driving past a famous art museum and saw a banner advertising "Art for a More Just World." Art has no chance of making the world "more just" than politics has of making it more beautiful. Who is to say what is just? The courts, according to the law. Are they unjust? Of course. As are all human endeavors.

The inspired curators mean that they are presenting confections *communicating the idea* that this or that group suffers and that this or that solution is obvious and would be adopted save for the cruelty of this or that other group. But, though it paid the rent of the curators, and perhaps saved the soi-disant artists from getting a job, who among the viewers benefited? Answer: *all* of them, for they attended as a performance of righteousness.

Art has no purpose, but it has a use. The oyster cannot use the pearl; observers may admire its beauty, but that does not allow them to understand the pearl, beauty, or the oyster.

The museum banner irritated me, or, better, piqued my now constant state of irritation. The Yiddish proverb has it that an old woman in the house is a blessing, whereas an old man in the house is a curse.

As Mr. Yeats had it,

> *Observant old men know it well;*
> *And when they know what old books tell,*
> *And that no better can be had,*
> *Know why an old man should be mad.*

TUG-OF-PEACE

Underemployed educators have recently suggested that school games breed the urge for conflict. But school games, which of course *are* conflict, have been observed, by any who cared to watch, to divert excess energy into outlets not merely nondestructive but creative: physical health, the formation of team spirit, an appreciation of excellence, and so on. These school lessons survive past all remembrance of European history, literature, and other mixtures of fact and opinion.

The current fashionable "reconsideration" of school sports is an attempt not to cure a problem but to cure a solution. An examination of this misguided jollity may yield some useful insight.

Some school officials, noting that war is bad, have ruled that tug-of-war be renamed tug-of-peace.

Consider two opposing teams, pulling on a rope, a game we will call tug-of-peace. At the conclusion of the contest, what will the stronger team have demonstrated? That *their* vision of peace (the game's title) has irrefutably prevailed over that of their opponents. This is, of course, the definition of war.

"Peace" may always be found through submission, which, in the case

of games, is called "defeat," or in war "surrender," which the pacifist experiences prior to the contest as reason, and afterward as slavery.

All the above states are only temporary, for the only total peace is in the grave. Victor and vanquished, pacifist and warrior, tug-of-war and tug-of-peace, all are the progress of Sisyphus. Save death, there is no human completion that is final. Those offering the same will be found on the continuum of fools, ideologues, purveyors of snake oil, and the thugs and dictators who, inevitably, supplant them. The aggressor suggests parlay as a cost-free *ruse de guerre*. Any considering his false flag approach have just been defeated.

A sporting event is not only a contest of strength and will but, enjoyed vicariously, a celebration of the essence of human life, which is the play of antagonisms.

That contact sports are currently disparaged as promoting violence is a late-appearing sign of a culture narcotized by prosperity. We see this in the realm of foreign politics, in the noble proclamation that we would be better off if we all just "got along," this is to say, if the culture, momentarily feeling fat and sassy, simply shared with its aggressors its perception that "we all want the same things" and invited them to name those things identity.

A most loathsome example of meddling in sports is the Left's destruction of those hard-won women's rights specified under Title 9. The destruction of women's athletics in the name of fairness is, just like the West's ignorant indictments of the State of Israel, a denial of legitimate effort and accomplishment—holding, in effect, that playing fair is cheating.

The derogation of Israel is anti-Semitism, the destruction of girls' and women's sports is misogyny. Tug-of-peace is, finally, the attempt not to ban war but to demean those struggles with incontrovertible outcomes. I will refrain from naming the late election.

Orwell posited 1984 as a year of accomplished dystopia. Here peace is war, and freedom is slavery. Given two thousand years of Judeo-Christian culture, he erred by only 1.25 percent in his prediction.

We may rename tug-of-war tug-of-peace not only in the schoolyard but in the Middle East, where perennial indictments of the Jewish state are called the peace process, just as in our cities where the Left insists that riot, violent thuggery, and theft may be assimilated if *just renamed* "protest."

But hypocrisy, the unresolved remainder, must be accounted for, just as in any mathematic equation. The victims of newspeak, whether the shopkeepers bankrupted by riots or diaspora Jews forced to confront anti-Semitism, must either submit (which is to say *repress* their shock and outrage) or rethink their position.

In the first case, the repressed perceptions must emerge as hatred of those who have *not* submitted—their stalwartness, of course, an affront. This is an effortless and logical choice. The second case, however, sentences the individual to some effort and pain. It is called freedom.

The Old Testament is known as the Five Books of Moses. His is the story of repression. For everything in his life has been renamed. He is an infant Jew, scheduled for slaughter. He is saved and raised as an Egyptian prince, but witnessing the persecution of the Jewish slave, he defends the Jew, and Pharaoh notes his choice.

All his life, the Egyptians have been trying to murder him every time he identifies as a Jew. He realizes it, resigns, and flees to the wild. He can no longer pass as Egyptian, and because he *knows nothing of the Jews*, it does not occur to him to live among them. (See today's Jewish leftists.) So he becomes a recluse. Then, one day, he sees a bush that burns but will not consume itself. God speaks to him from the bush and tells him to return to Egypt and to free the Jews.

What is the burning bush, which will not cease burning? It is his mind. He was living a lie in the comfort of the palace, and he is now living a lie in the illusion of "uninvolvement." The bush will not stop burning until he confronts the truth.

The truth of an existential struggle cannot "lie somewhere in the middle." Between war and peace, there must be one outcome or the other. As there must be between freedom and slavery.

THE AWL THROUGH THE EAR

The autos-da-fé of the Inquisition were primarily meant not to punish but to *dissuade* from heresy. We saw the same today in the hounding of President Trump: "If we can do this to the most powerful individual in the world, what do you think we can do to *you?*"

The strategy is that noted by Musashi (1584–1645), Japan's greatest swordsman, in his martial arts classic *The Book of Five Rings*. The strategy called "to hold down a pillow" means to beat your opponent so thoroughly that he will not dare to *entertain* thoughts, nor even fantasies, of revenge.

This is the purpose of terror: to break the will not only of actual but of any potential adversaries so that they, to preserve some self-respect, must come to accept and *endorse* strictures as laudable—in effect, to induce the slave to love his chains.

In Genesis 15 the servant is offered his freedom but protests that because he loves his wife and his children, he would rather stay and serve his master. The master then takes the servant and puts an awl through his ear, binding him to the door, and the servant will remain a slave forever.

The servant explains his temerity as love for his family; he does not choose to sacrifice his current place (slavery) for the unknowns of freedom. The awl through the ear is interpreted (inter alia) as a puncturing of the eardrum to allow the master's offer of freedom to enter.

Now we are engaged in a great civil war. *The offer of freedom* (American constitutional democracy) is at issue, and the tyranny of the Left displays the carrot and the stick to a legitimately disturbed populace. The stick is blacklisting, hounding, legal actions, and will, if unchecked, mature from cultural into *legal* denunciation followed by imprisonment and then into licensed murder. The carrot is an acceptable explanation for submission. Such, we are told, is neither cowardice nor passivity but a legitimate concern for human values.

These values are those neither of religion nor of the Constitution: they have no proof text, and so may be alleged ad lib. Further, the individual, rewarded for compliance, sees the added honor of *invention*. If it is laudable to treat women and men equally, how much more laudable to treat women as superiors and, the human need for novelty being insatiable, to proclaim then that there *are* no women, nor men, and then, as heard on the floor of Congress, that it is reprehensible to refer to "mothers and fathers," and so on.

This progression is both the carrot and the stick of tyranny: offering safety through acceptance of heresy, and promotion for its elaboration. The progress toward slavery can end either with the defeat of the terror or with its complete mastery of the organism attacked.

The Right has been hamstrung in resistance by adherence to law; for, to a conservative, what greater crime than adopting terror (the rejection of law) to preserve law? (Compare this from the Vietnam War: "We destroyed the village in order to save it.")

The COVID epidemic and the riots were the bad fairy at the cradle of a conservative constitutional rebirth—that is, a government of, by, and for.

Lincoln's peroration has always been mispronounced. We heard and repeated it with emphasis on the prepositions, because that is a pleasing

rhythm. But his intention was, and must be understood as, homage to the noun: that is "of the *people*, by the *people*, for the *people*."

Political tongues love to assert of their candidate the ability, and of his opponent the inability, to "unify" the country.

But what can this mean?

If we understand it to mean complete unanimity, such can be found only in a slave state. Should it mean universal agreement, we cannot achieve "unity" even in our families. The family, the workplace, the community, and the nation are composed of disparate individuals and their amalgamation into factions. Such disparity of opinion is not only inevitable in politics; its acceptance is a sign of health.

When all politicians are agreed, someone is getting bought off, for how can the interests of their various constituencies be identical? Only if that identity is the love of money and power.

The Constitution exists not to provide "unity" but to assert and demand the subjugation of unbridled interest to previously agreed-upon laws (and so, perceived or not, to the underlying customs upon which the laws are based).

Elected federal officials take an oath to uphold the Constitution. When they aren't held *strictly* to that oath, we have that anarchy we see metastasizing around us.

The constitutional oath must take precedence over party politics. Is such possible? No. That's why we have elections: to throw out the last bunch of bums and try again.

Boss Tweed and his Tammany Hall ran New York City and state politics in the late nineteenth century. He was convicted of stealing between $200 and $400 million from various government coffers. Prior to his conviction, his unopposed power was so great that few even fantasized about opposing him. His motto, adopted by today's congressional Left, was, "What are you going to do about it?"

The answer, then as now, in Daley's Chicago, Tweed's New York, or Pelosi's Washington, was, "Nothing, Boss, not me. *But*, if I might be of service, *look over there!*"

For the cowed individual, denunciation, if it will not finally protect, might in the moment serve to distract the Jacobins. And how delightful if such also carried the merit of righteousness.

I see where a union of flight attendants has passed a resolution to staff no flights that carry "insurrectionists." But who are, or were, the insurrectionists? And what was the "insurrection"? There was vandalism in the halls of Congress, a Capitol police officer was killed, and some poor woman died. But if this were the tragic end of a peaceful, lawfully protected demonstration, how could the flight attendants assert their righteousness? And who among the flight attendants would be in charge of determining who *was* an insurrectionist? By what definition, on access to what information, and with what hope of appeal?

So we see the victims of cognitive dissonance, shocked into asserting identity with the, to their mind, new Pharaoh. The teachers' unions, similarly, are pushing for a California law outlawing private schools. And we find, online, an ad showing a teacher in a mask, the T-shirt reading, "I can't teach if I'm dead."

Well, no one can do anything if they're dead, but more important, the teachers couldn't teach when they were alive, and during the pandemic they wouldn't teach, although they still collected rent from the taxpayers.

An aviation industry magazine published an article by a highly placed Black female executive on "how to deal with white males." What is this technical and respected magazine doing publishing a lesson about identity politics?

Here is an explanation from the *Ziegfeld Follies*.

Bert Williams was the biggest star on Broadway. He joined the *Ziegfeld Follies* in 1910 and, among his various triumphs, put over this gem.

> *Ivory bones with ebony dots*
> *Oft lead to cemetery lots*
> *A game last night brought on a fight.*
> *Which finished up with pistol shots.*

I was the furthest from the door
The others all got out before
A body on the floor lay dead
And thro' the transom someone said:
"Somebody's got to stay behind
Somebody must remain;
And, when the officers arrive
Explain how came he ain't alive
The man who stays and sees it thro'
Gains notoriety."
It was a wonderful chance for somebody!
*Somebody else, NOT ME!**

* —From "Somebody Else, Not Me" (Lyrics by Ballard MacDonald)

GOODNIGHT, IRENE

———— ❧ ❧ ————

"So men ate, and drank, and laughed, waiting till chaos
should come, secure in the belief that the atoms into which
their world would resolve itself, would connect themselves
again in some other form without trouble on their part."

—Anthony Trollope, *North America*, 1861

We might mock or scorn or pity cults convinced that the end of the
world is at hand.

That individuals might sell or abandon all they own and gather on
a mountaintop to await the Rapture is puzzling, but their folly is not
far removed from our day-to-day devotion to new-discovered salvations:
wealth-management schemes that are the philosopher's stone and inert
white creams sold as the elixir vitae.

But when we have acted like fools, we have a fail-safe mode of mem-
ory. The inhabitants of Salem village, after the eighteen-month-long hys-
teria,* simply *forgot*, as a community, that which there was no way to
explain. The Germans, a handy people, reimagined their national sav-
agery as victimhood and today characterize the war years as an occupa-
tion by the Nazis.

Since Napoleon's victories, the national motto of France seems to

* With thanks to Stacy Schiff, *The Witches* (2015).

have been "Nous sommes trahis"; citizens of the Confederacy, and their descendants for over a century, solidified their community through identification with the Lost Cause, as did the Jacobite Scots.

Not only was Harvey Weinstein, characterized as "God" by a revered actress, forgotten, but the actress's egregious comment is, too.

Freud said that the only way to forget is to remember, but his disciples the songwriters Alan Berman, Marilyn Bergman, and Marvin Hamlisch wrote in "The Way We Were" (1973), "What's too painful to remember, we simply choose to forget."

We might imagine how the eschatologists came to find themselves upon that hill from which they would be magicked into paradise.

But how did they get down?

How did the unfortunate fact of their continued existence mesh with their brave and supposed terminal devotion?

Must not their leaders, canny and persuasive enough to get them *up* the hill, have improvised an acceptable (if necessarily inelegant) explanation of their continued life? For example, "The world we *knew* had died: If you examine your hearts, you will find them *changed*, and your minds are likely full of wonder at what you might consider your continued existence. The predicted cataclysm *has* taken place, but we *alone* among humanity have been allowed to understand it."

Why would a group pleased to accept the first premise balk at accepting the second? Would they not come down the hill and greet their neighbors' glee not with shame but with pity—those poor fools who did not realize the world had come to an end—that it was just a matter of definition?

Religious and pseudo-religious groups throughout history have gathered into this or that field to enjoy a communion of the last moments.

The urge to get together and walk around is still with us as Walks Against: Systemic Racism, Cancer/Oppression, President Trump.

The date of each Armageddon ticks past; the congregants, like the

folks waiting on the hill, *must* forget the failure of their prognostications and move on.

Educated contemporaries shake their heads over medieval fears of the comet's tail and believe the world is ending because of global warming.*

As their prognostications fall past due, the new threat replaces the old, and the old is as forgotten as Harvey Weinstein. (Who recalls the terror over the swine flu, heterosexual AIDS, or the Y2K bug? And the COVID pandemic will, in time, be added to the list.)

Are today's Westerners more foolish than our forebears? We cover our faces with wisps of cotton, hoping to outwit a virus as ancients tied garlic around their necks to protect them from werewolves and carried clove-scented handkerchiefs to ward off bubonic plague.

No, we are not less ignorant than our predecessors, but we have had one excuse they lacked for our herd inanities. It is the atomic bomb.

Mine was the first generation in history to grow up under the actual possibility of instant global annihilation. We who as children hid under our desks as protection from incineration have carried the fear—now active, now momentarily dormant—through our lives. Mass media and politicians since the bomb have commercialized panic to sell merchandise or to gain power.

Here are two cataclysmic visions from the early atomic age. *On the Beach* by Nevil Shute (1957) takes place in Australia. A nuclear holocaust has wiped out all life in the Northern Hemisphere. The prevailing winds are blowing fatal fallout south. The Australians go about their business with

* "An Evangelical who thinks the world is ending is called a religious fanatic; a liberal who thinks so is called an environmentalist."—Dennis Prager

dignity. Families are supplied with lethal pills and syringes with which to inject their infants. An American submarine, based in Australia, sets out on a reconnaissance mission to the North and finds all human life gone. They return, to the matter-of-fact sadness of the earth's last humans, a common greeting, "It won't be long now."

And here is the one that terrified me:

The *Twilight Zone* episode "The Midnight Sun," aired November 17, 1961. The earth is thrown out of its orbit by a nuclear explosion; it is burning. A young woman and her landlady are among the last residents of New York, the others having fled north, died in the heat, or committed suicide.

The two women watch the paint bubbling on their walls and say their goodbyes. The younger falls into a final coma. She awakens to find it had only been a dream. Her, and our, moment of relief passes when we realize and she now remembers that the earth is actually freezing and that she will soon die of the cold.

Here is the closing narration (written and delivered by the show's creator, Rod Serling): "The poles of fear, the extremes of how the earth might conceivably be doomed. Minor exercise in the care and feeding of a nightmare, respectfully submitted by all the weather-watchers in the Twilight Zone." (With thanks to Wikipedia.)

Over the last year I've often wondered, and perhaps you have, too, if we are *actually* living in a dream.

Writers of combat-porn novels often resort to describing the hero's state of mind in a gunfight: "'Oh my God,' he thought, 'this is *just like a movie.*'"

But the continual shocks of the last year do not feel like a movie—at which, after all, we are assured that, finally, everything will be put to right.

The last year feels like a dream. And many of us have wondered, on waking, "Imagine if this were actually *happening* . . ."

I refer not to the retail symptoms—a pandemic, riots, an attempted coup, the terminal corruption of elected officials and their masters and

stooges—but to an underlying horror so terrible that occupation with these symptoms is a relief.

We may, as per taste, accept, deny, or rationalize the last year's events piecemeal: a choice less devastating than to understand their conjunction as the death of the West, which it may be. Or of the West that we knew, which it is.

RECESSIONAL

God of our fathers, known of old,
Lord of our far-flung battle line,
Beneath whose awful hand we hold
Dominion over palm and pine—
Lord God of Hosts, be with us yet,
Lest we forget—lest we forget!

—Rudyard Kipling

My grandfather was born before the invention of the automobile. At my birth there were still alive many veterans of the Civil War and many who had been slaves. I've witnessed the creation of the internet and the death of the cities. Age has given me some leisure, experience and the material for reflection.

Civilizations persist through *intention*. The ambition to create, to achieve, to expand, finally, to breed, to worship, to understand, is *eros*: the longing for the other.* God directed human beings to be fruitful and multiply, and addended rules and insights for the lawful control of that urge. The denial of our human nature leads to a rejection of the rules for its control, and so of the Creator of both. But the denial does not

* Allan Bloom, *The Closing of the American Mind*.

eradicate human nature; it merely proclaims the individual, in his wisdom, as exempt from it. Idolatry is the conviction of exemption.

We human beings are cunning but rather stupid. We are herd creatures, no less than our dogs. Our biddability, our desire for inclusion, and our ineradicable capacity for self-delusion lead us into error and folly, which lead us to sin and self-destruction.

Great and ordinary Americans lived and died to end the horror of slavery. Ended, the tool was taken up again as segregation and Jim Crow. Segregation resurfaced as apartheid called "diversity"; power is now usurped not through the practice but through the *accusation* of racism, and the possession of the hammer creates the delusion that everything is a nail.

The emergency room doctor is presented with a casualty for whose benefit he must apply a formal and limited progression of tests and observations to lead him, quickly, to a diagnosis and so to action. Is the patient breathing, conscious, bleeding; what is the temperature, the pulse, the respiration rate? Neither the doctor nor the patient has the time for abstractions. It is not the doctor's job to consider the patient's general health and lifestyle, nor to form plans for their reformation. The doctor's job is *to see that the patient does not die in the emergency room*—a process for which he is fitted by the strictest of indoctrinations in this idea: there are only so many ways in which the body can go wrong.

This, applied to the body politic, is the great lesson of the Constitution.

The Torah, the Old Testament, is a course of study in the disease of human consciousness, which is to say in human nature. It begins with the sin of the first humans. This prologue explains what we will find in the elaboration. The sins and errors of the first humans are found again in their progeny: arrogance, cowardice, duplicity, ingratitude, greed, lust—we all know them all.

The Gospels teach that after this life one may go to a better place.

But will we be conscious of it? When this was a better place, were we conscious of it here?

Some were.

I never understood the religious ceremony called "a renewal of vows" as it applies to marriage, but I understand it now as needed between citizens and the country that is, finally, just our conjunction.

The great poets were philosophers—that is, men of constant sorrow. Even the love poems of Yeats, the greatest English poet since Shakespeare, are touched with grief.

"Man of Constant Sorrow" is a southern folk song of the early twentieth century. It is, like the songs of Huddie Ledbetter and of Hank Williams, poetry equal to that of Yeats.

It is as incomplete to characterize the blues as Black history as it would be to refer to film as "Jewish history"; both combined to form the American character, a 250-year-long confection of effort, achievement, sorrow, valor, and crime, like that of any other country, save that it is the story of *our* country, the freest and most prosperous in history.

I've been fortunate enough to've lived here all my life and have been playing on the house's money for fifty years. God bless America, "stand beside her, and guide her."*

Some further Jewish wisdom: "If you do not heed Me, and do not keep all these commandments, if you mock My decrees and tire of My laws you will have broken My covenant. Then I will do the same to you. I will cause you feelings of anxiety, depression, and exhaustion, making your life hopeless. I will send the plague upon you . . . I will let your cities fall into ruin, and make your sanctuaries desolate, so that even your enemies who live there will be astonished . . . I will bring such insecurity upon you that those who survive in your enemies' land will flee from the sound of a rustling leaf. They will fall with no one chasing them" (Leviticus).

* Irving Berlin, born Israel Beilin, Tolochin, Russia, 1888.

The Bible teaches that the panic of prosperity is not a cultural outlier but the *inevitable* sequel to the rejection of the holy, that is, of gratitude.

It resembles the panic of scarcity. This may lead to hoarding and, in its extreme forms, to theft, and even to cannibalism. The horror of hunger may be stilled by food, but where is the substance that can assuage the *panic* of overabundance? We may address a supposed lack of potable water by importing it from Fiji, and confront our terror of carbon emissions by buying luxury electric cars, but how may we do so *without disposable income*? And we may simultaneously proclaim that property is theft, but no one (Marx included) ever understood this to mean other than someone *else's* property.

The old joke had it that money can't buy poverty, and indeed it can't, and the anxiety of prosperity can't be cured by buying "more" of anything, *including* buying exemption through squandering funds upon those causes self-proclaimed as "good." Proclamation won't cure our fear; if it could, why would it require eternal repetition?

We have indicted *use* and glorified the poor, the underclass, the homeless, the Palestinians, convicts, illegal immigrants, because they possess, to the liberal understanding, that which they may not: *poverty*, which alone, to the unseated mind, can arrest the panic of having too much.

Trump was vilified with greater vehemence than anyone in Western memory. He was hated because he was feared—because he held that prosperity was to be enjoyed as the legitimate reward of sacrifice, struggle, patriotism, and the American culture that was their conjunction.

But reason can't still panic, and the horror of plenty stampeded the West. Panic, as any of us who've felt it know, swamps the intellect and turns us savage.

If we are lost in the woods and freezing, hypothermia may set in, lowering our core temperature and stealing our mind: the panicked individual runs here and there, tearing off his clothes, and is discovered, naked, frozen, and dead, five yards from the road he has found, crossed, and abandoned.

The terrified individual in the group submerges his reason in una-

nimity. Having lost his mind, he is reduced to a near-animal state and will choose extinction in company over exclusion.

Armed forces officers carried pistols into combat, not as an offensive weapon, but to shoot mutineers, because mutiny, in a terrified group, spreads on the instant.

The Left blacklists, cancels, and indicts contrary opinion for exactly the same reason. Not in opposition to dissent, but to dissuade from mutiny—that is, to behavior that threatens the existence of the group. The Left identifies the group as Humanity, but, finally, it is just the Left.

The Old Testament is, first to last, the report of mutiny, which is to say of human nature: dissatisfaction with our lot, indictment or denial of a deity who would doom us to humility, consideration, piety, and restraint.

The Levitical warning closes with God's promise that, though He chastises our failure, He will not desert us: "I will remember My Covenant with the Original Ancestors I brought out of Egypt, in sight of the Nations, so as to be their God."

The struggles and anguish of the Jews, of the West, of America are, historically, a recitation of failure, heresy, folly, and sin, interspersed with odd instances of heroism. Our American covenant, like any covenant, is aspirational. It is a reduction of biblical wisdom to practical political language like the Constitution.

The tumult and the shouting dies;
The Captains and the Kings depart:
Still stands Thine ancient sacrifice,
An humble and a contrite heart.
Lord God of Hosts, be with us yet,
Lest we forget—lest we forget!

—Rudyard Kipling, "Recessional"

ACKNOWLEDGMENTS

Much of this material appeared previously in *National Review*. I am indebted to its editors for their support and endorsement. As I am to my agent David Vigliano, and my assistant Pam Susemiehl.

INDEX

ABOUT THE AUTHOR

DAVID MAMET received the Pulitzer Prize for his 1984 play *Glengarry Glen Ross*. His other plays include *American Buffalo*, *Oleanna*, *Speed the Plow*, *Race*, *The Cryptogram*, and *November*. His screenplays for *The Verdict* and *Wag the Dog* were nominated for the Academy Award.